A PORTRAIT OF
VANCOUVER ISLAND

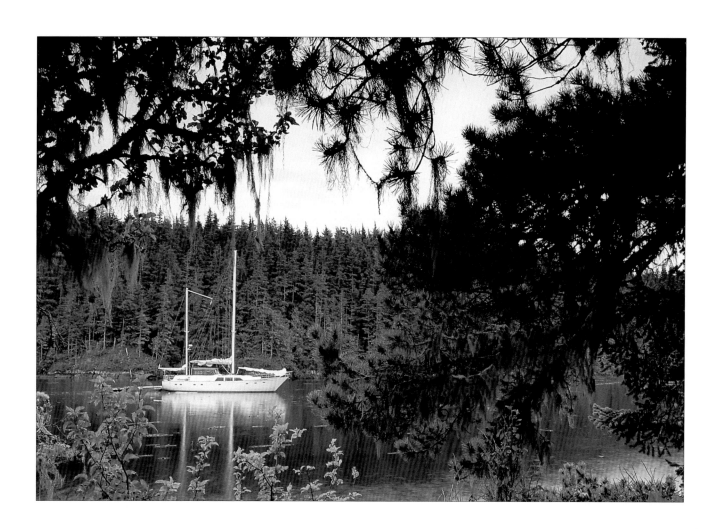

by

Chris Cheadle

A PORTRAIT OF
VANCOUVER ISLAND

Canadian Cataloguing in Publication Data
Cheadle, Chris, 1957-
A portrait of Vancouver Island
ISBN 1-55153-152-6 (bound) -- ISBN 1-55153-153-4 (pbk.)
1. Vancouver Island (B.C.)--Pictorial works. I. Title.
FC3844.4.C44 1998 971.1'204'0222 C98-910084-7 F1089.V3C44 1998

front cover:

Amphitrite Point, Barkley Sound, Ucluelet

back cover top:

The Empress Hotel was completed by the C.P.R. in 1908. Its "afternoon tea" is a world-renowned attraction.

back cover bottom:

A visiting gray whale delights these bold canoeists in the water near Sidney.

page 1:

A cruising sailboat in a quiet anchorage in the Pearse Islands, northern Johnstone Strait

page 2:

A pod of resident orcas cavorts in Haro Strait near Victoria, with Washington's Olympic Mountains beyond.

page 3:

Two "Spirit Class" BC Ferries, which move travellers between Tsawwassen terminal (Vancouver) and Swartz Bay (Victoria), pass in front of Mayne Island by Active Pass.

Production:
Art direction/design Stephen Hutchings
Design/layout Kelly Stauffer
Editor Sabrina Grobler
Financial management Laurie Smith

 Altitude Green Tree Program
Altitude will plant in Canada twice as many trees as were used in the manufacturing of this product.

Printed in Canada by
Friesen Printers

We acknowledge the financial support of the Government of Canada through the Book Publishing Industry Development Program (BPIBP) for our publishing activities.

VANCOUVER ISLAND

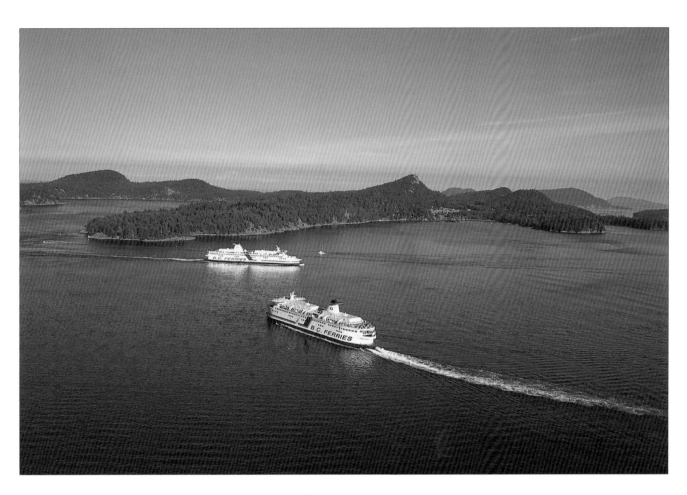

Contents

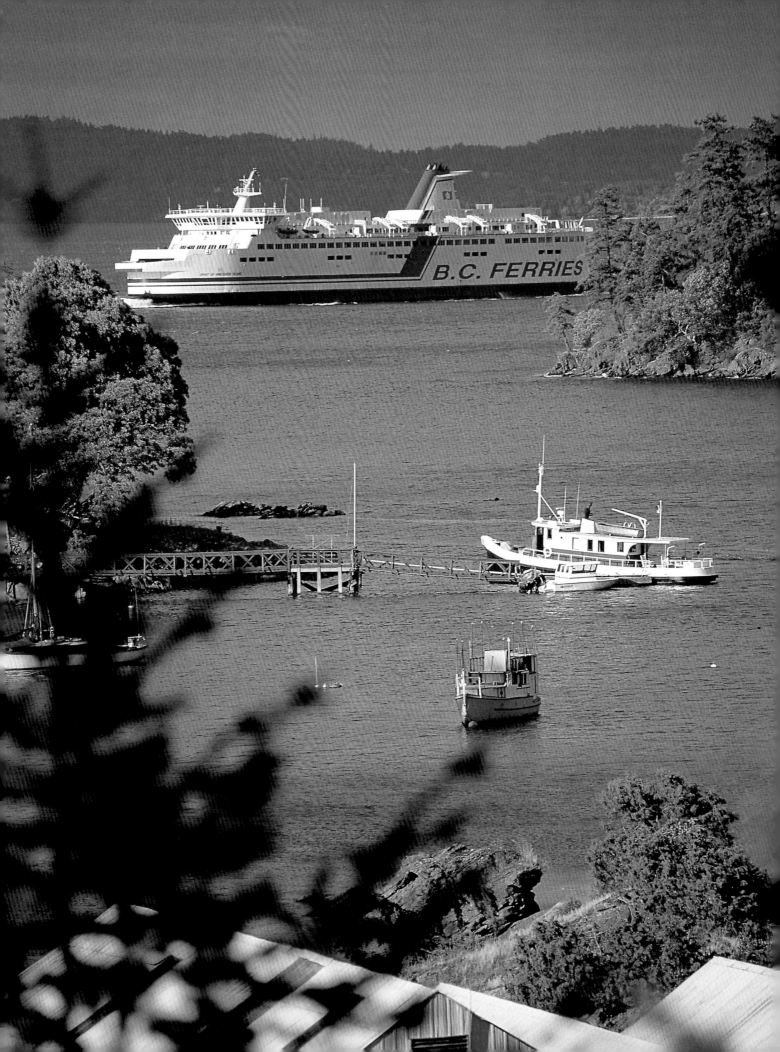

INTRODUCTION

Top: "Heaven Tree," a massive Sitka Spruce that stands in the protected first-growth forest of the Carmannah Valley

Opposite: M.V. *Spirit of Vancouver Island* passes Canoe Cove approaching its Victoria arrival at Swartz Bay Terminal.

For me, it was love at first sight. Twenty years ago I arrived on Vancouver Island, jumped on a bike and quickly discovered the quiet beaches of Saanich Inlet and the farmlands of the Saanich Peninsula over the next several hours. The next day I drove north, past the sweeping, mountain-fringed vistas of the Malahat. I wandered, in awe, in the shade of the towering Douglas fir trees of Cathedral Grove. I swam in the cool, emerald pools of Kennedy River. As I caught the first glimpse of the foaming surf through the spruce fringe at Long Beach, Pacific Rim National Park, my heart raced. I stopped, hiked out to Schooner Cove, and pitched a tent amidst a tangle of massive driftwood logs to the rhythm of the ocean's timeless, ceaseless roar. This was it. I was home.

This picture of serenity belies the Island's violent birth. Rocky mountain ridges rising 2,200 metres high at Strathcona Park's Golden Hinde were thrust from earth's crust hundreds of millions of years ago. At 450 kilometres long, this largest island off the Pacific coast of the Americas was formed as a microcontinent on its own shifting plate, surrounded by the teeming

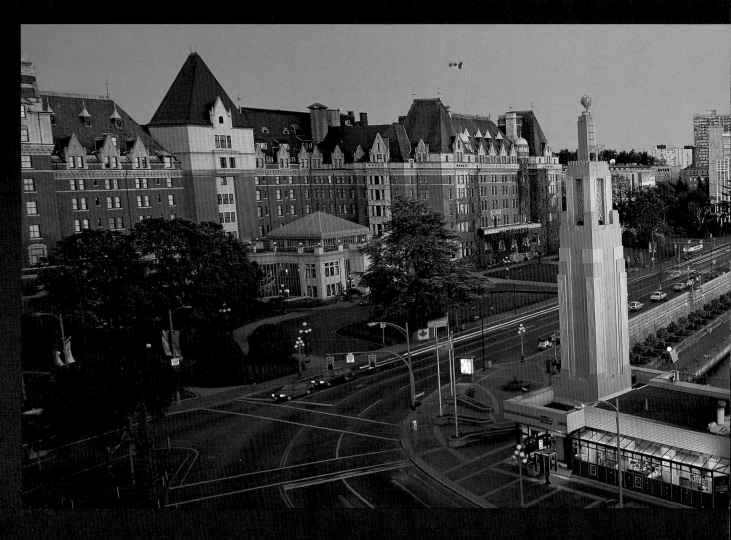

waters of the North Pacific. Miles of thick ice have shaped the Island's topography, forming valleys and depositing great sandy beaches on its shores. Dinosaurs and woolly mammoths have roamed this great land.

Humankind arrived, ancestors of the First Nations, over ice bridges from the Bering Sea some 10,000 years ago. Over time, three different cultural groups evolved, each occupying distinct geographical areas of the Island. All, however, reaped the bounty of the richest biomass ecosystem in the world.

The Nuu-chah-nulth, formerly called the Nootka, are the sturdy peoples of the exposed Pacific coast, on the west side of the Island. Occupying the north and northeast quadrant of the island from Cape Scott to Campbell River and the adjacent islands and mainland areas were the Kwakwaka'waka, more commonly known in the past as the Kwakiutl. Along the more temperate coastal plain below Comox to Sooke and in the Gulf Islands lived the Coast Salish.

Europeans, with the landing of Captain James Cook in 1778 at Nootka,

Top: Panorama of Inner Harbour, Empress Hotel and sailboats

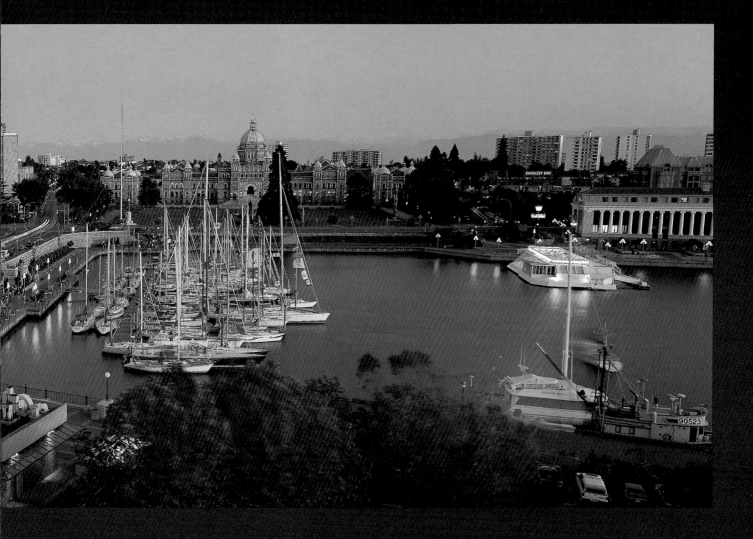

ushered in the modern age. Prized sea otter pelts drew dozens of Russian, Spanish, American and British trading ships to this coast. After wrangling with the Spanish over the territory, the British prevailed and ceremoniously hoisted the Union Jack at Nootka in 1794. The relocation of the Hudson's Bay Company headquarters from the Columbia River to Fort Victoria in 1843 began a settlement trend among Europeans that today makes the Island home to over 500,000 citizens.

The following 150 years of logging, mining, fishing and farming established towns and roadways that crisscross Vancouver Island. Today, tourism, recreation and a renewed respect for ecology and First Nations rights and values are attractions that draw visitors from around the world to Vancouver Island.

It is with great pleasure that I am able to share my impressions of Vancouver Island with you. I hope you will discover for yourself some of the delights of touring this wondrous place I call home.

Chris Cheadle, 1998

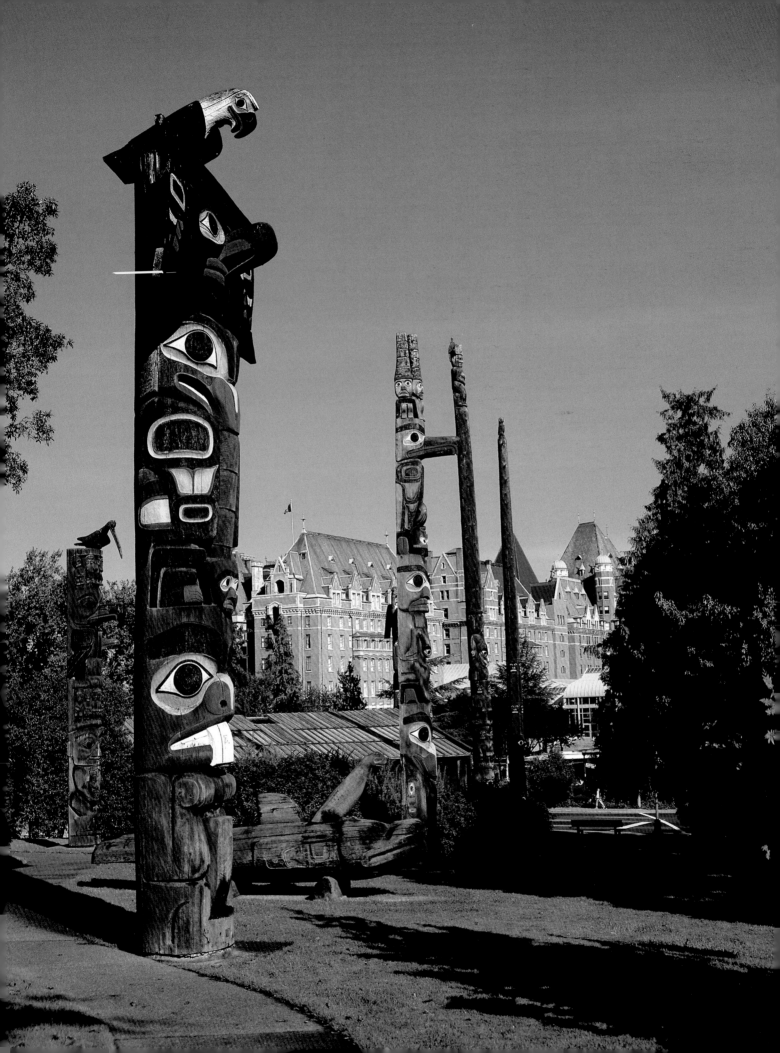

VICTORIA

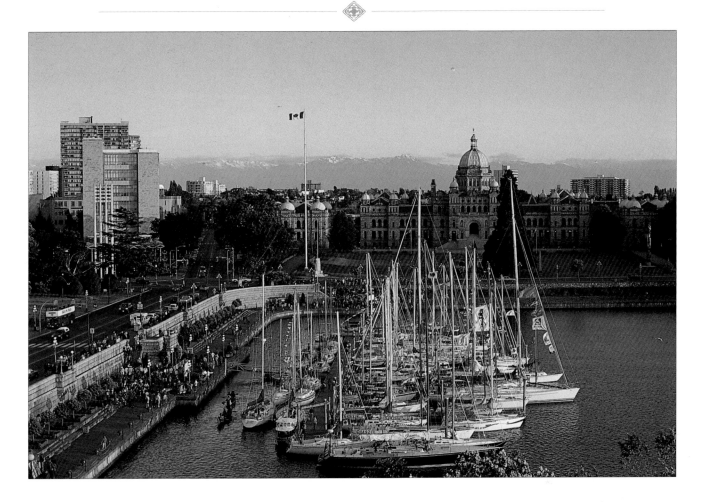

Top: Colourful banners fly from the yachts awaiting the annual Swiftsure Classic sailboat race, in Victoria's Inner Harbour.

Opposite: Thunderbird Park, with the Empress Hotel beyond, features various First Nations totem poles on its grounds behind the Provincial Museum.

U nder James Douglas, Victoria's colonial settlement began as Hudson's Bay Fort in 1843. This promising new territory appeared to Douglas as "a perfect Eden in the midst of the dreary wilderness of the Northwest Coast." Prospects for establishing farms were ideal. Sheltered from the North Pacific by the island's western mountains, the gentle Mediterranean climate was a welcome respite from the arduous conditions that typified most HBC settlements.

By 1849, Vancouver Island was made a Crown colony. As a gateway to the gold fields with a growing population of British, Scottish, Irish, American, African American and Chinese, Victoria was in 1862 the largest western city north of San Francisco. Stately homes and estates rose as well-heeled colonists and retiring civil servants from Asia chose this as their new home.

A stroll through downtown Victoria to places such as Bastion Square testifies to this heritage. Market Square, Chinatown and Wharf Street, now colourful shopping and dining areas, were once the sites of raucous saloons, brothels, hotels, secret opium and gambling dens, and outfitting centres for

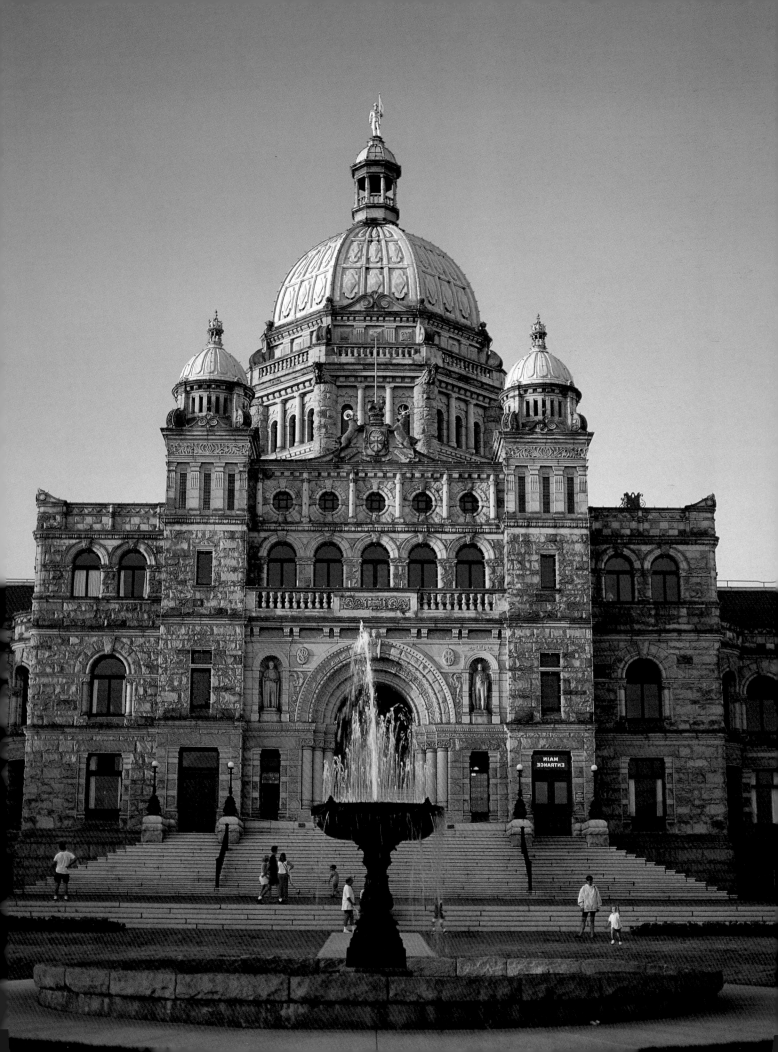

MAIN
ENTRANCE

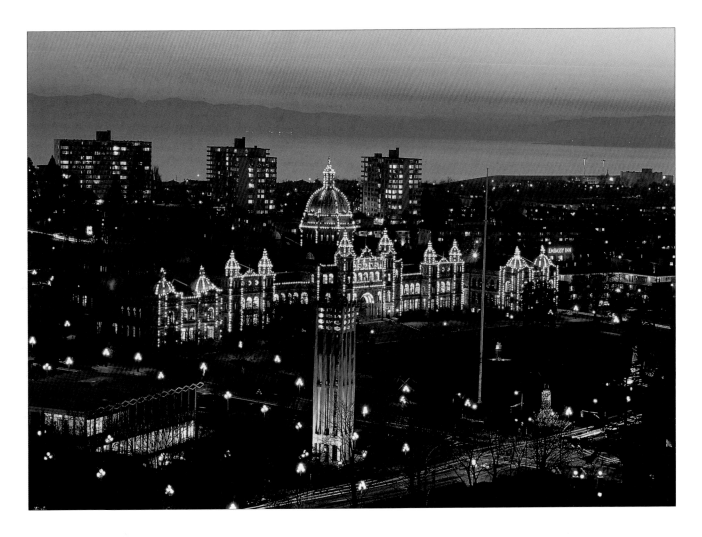

Top: Each evening, 3,300 glimmering lights outline the Parliament Buildings. The Straits of Juan de Fuca, separating Canada and the U.S.A., reflect the evening sky in the background.

Opposite: Completed in 1898, British Columbia's Parliament Buildings, designed by Francis Rattenbury, cemented Victoria's hold as the provincial capital.

sailors, sealers and gold-seekers.

As this important British colony grew, distinctive architecture, customs and gardening traditions took hold. A visit to Point Ellice House, near downtown and hosted by costumed staff, offers a glimpse of Victorian decor and gardens. Emily Carr House, Helmcken House and the Craigflower Farmhouse and Schoolhouse are also maintained for public viewing. Craigdarroch Castle and Hatley Castle, once deemed Canada's premier residence, are architectural testaments to the fortunes earned in coal mining by the Dunsmuir clan in the late 19th century.

Today, visitors stroll the causeway at the foot of Francis Rattenbury's Parliament Buildings. Musicians compete for the attention of the passing crowds. Yachtsmen relax, moored in the reflection of the Empress—another of Rattenbury's gems, completed in 1908.

The Royal British Columbia Museum, featuring the natural and human history of B.C., is nestled on the block between The Empress and the Parliament. It is considered one of the finest in North America.

The Butchart Gardens, north of the city toward Brentwood, showcases Victoria's horticultural brilliance. The site of Robert Butchart's former limestone quarry was transformed through the vision of his wife Jenny in the

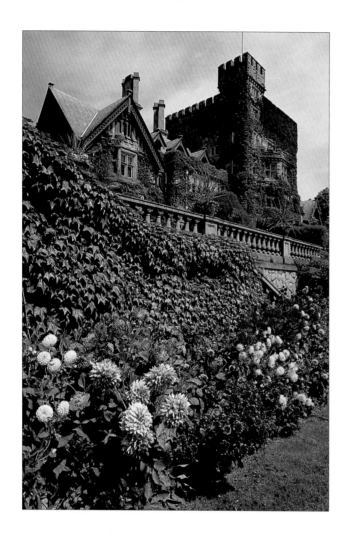

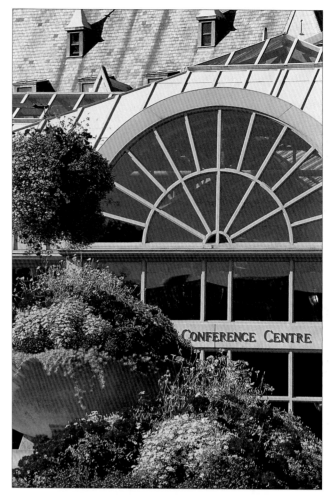

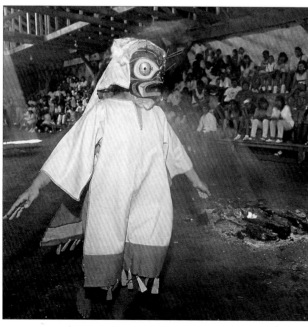

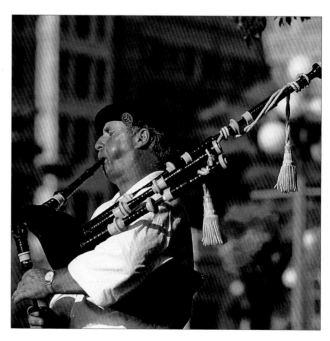

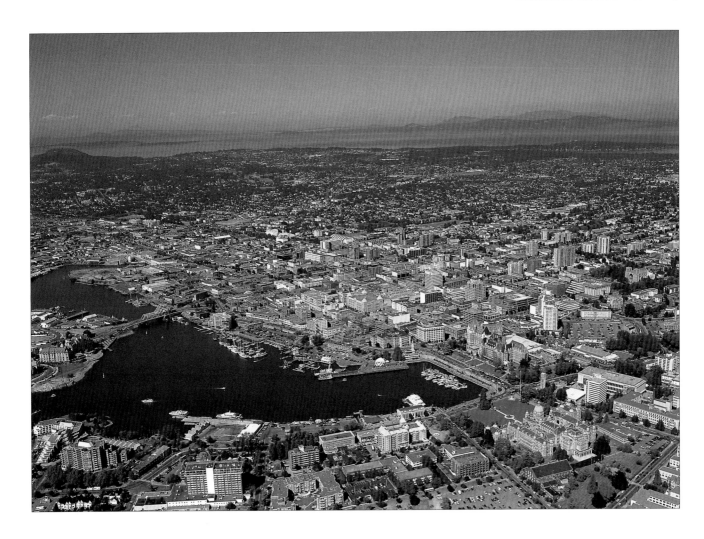

Top: An aerial view of Victoria's Inner Harbour

Opposite top left: Hatley Castle, built for Robert Dunsmuir in 1908

Opposite top right: Victoria Conference Centre

Opposite bottom left: A Kwakwaka'waka bumblebee dancer performs in the Coast Salish Leukwammon (Songhees) long house in Esquimalt.

Opposite bottom right: Wailing bagpipes greet strollers along the causeway on most summer days.

early 1900s. The 50-acre site now delights millions of visitors with its perfectly kept gardens, ponds and fountains. The gardens are even lit with thousands of coloured lights on summer evenings, and there are fireworks every Saturday through July and August.

Local waters, rich in marine life, sustain seals, sea lions, eagles and orcas. A network of spotters almost guarantees whale watchers a glimpse of the awesome *orcinus orca*, or killer whale. Dozens of charter operators run trips right from the Inner Harbour throughout the day.

The coastline of Juan de Fuca Strait provides a sample of what the Pacific shores have to offer. Esquimalt Lagoon, Witty's Lagoon, East Sooke Park and the Wiffen Spit at the entrance to Sooke Harbour are all a short drive from the city. Beyond Sooke, French Beach Provincial Park, with its surf-polished stones, is a good vantage point from which to see migrating gray whales. Other West Coast Road beaches such as China, Mystic, Sandcut Creek, Lost Creek and Sombrio can be reached by hiking down serviced, often rugged trails. At Port Renfrew, the sandstone shoreline of Botanical Beach is carved into unique bowls of intertidal life. This is best revealed at low tide, which usually occurs in the daytime between May and August.

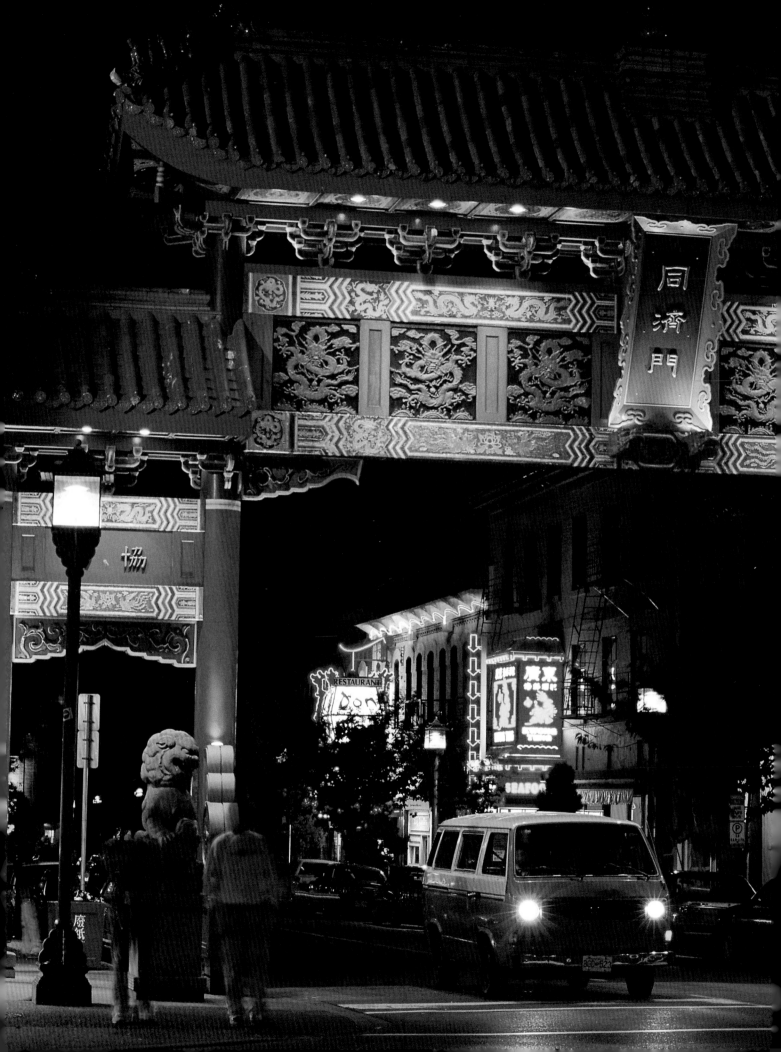

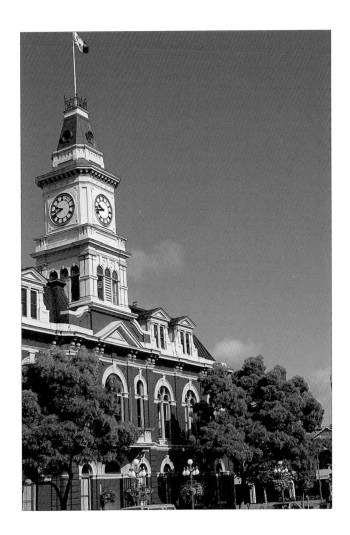

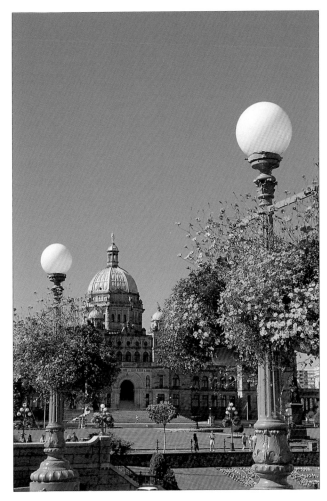

Top left: Victoria's City Hall

Top right: The "Garden City" brightens its streets with trademark lamp-posts and over 900 hanging flower baskets.

Bottom: The Empress Hotel was completed by the C.P.R. in 1908. Its "afternoon tea" is a world-renowned attraction.

Opposite: The Gate of Harmonious Interest marks the entrance to historic Chinatown.

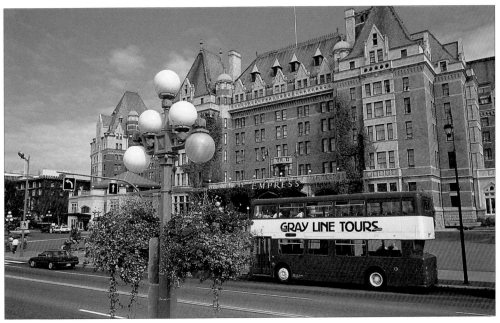

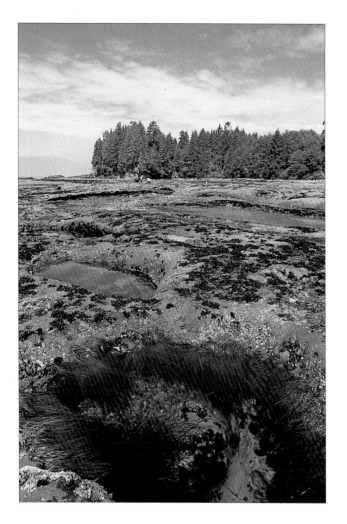

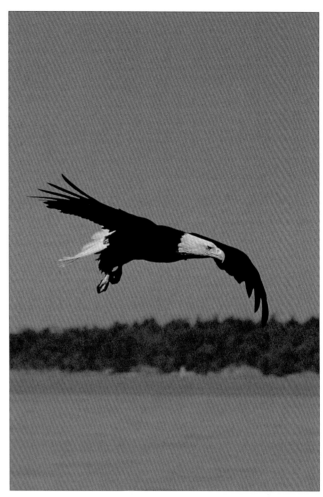

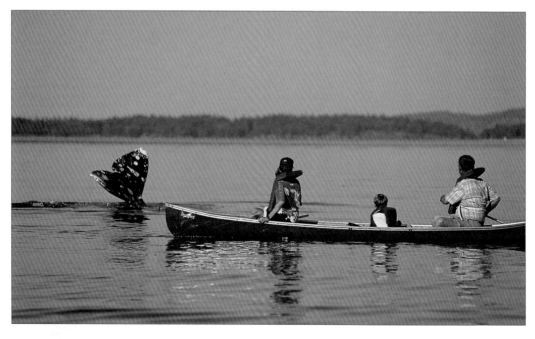

Top Left: Sandstone tide pools at Botanical Beach near Port Renfrew teem with marine life.

Top Right: Bald Eagles thrive on the rich marine ecosystems of the area.

Bottom: A visiting gray whale delights these bold canoeists in the waters near Sidney.

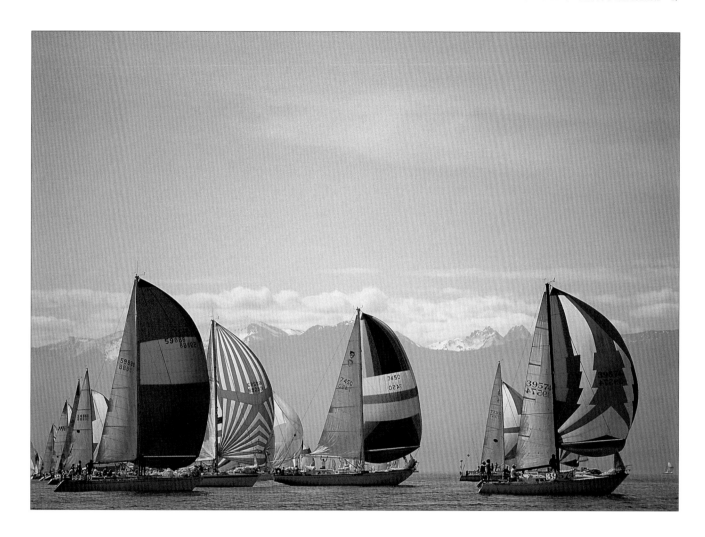

Top: A spinnaker start to the annual Swiftsure Classic festoons the Straits of Juan de Fuca with colour. Washington's Olympic Mountains loom in the distance.

Bottom: When the winds blow, the sail-boarders love to fly on the waves below Dallas Road at Beacon Hill Park.

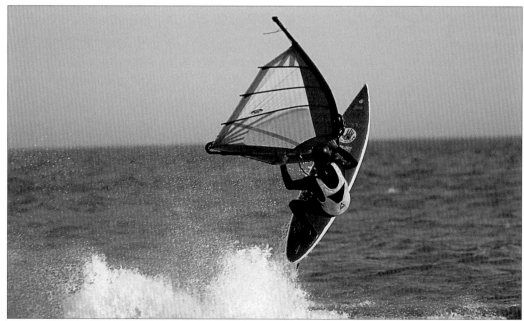

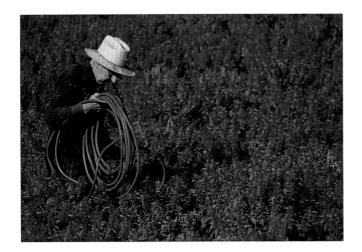

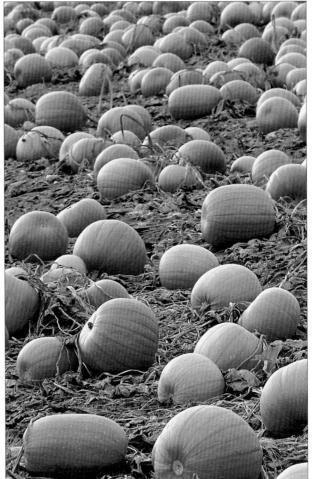

Above: October pumpkins await harvest on a Saanich Peninsula field.

Top left: Seed farmer Ernie Gait tends his salvia crop on the Saanich Peninsula.

Middle: The Saanichton Fair, held each Labour Day weekend, is the oldest in western Canada and features livestock, entertainment, agricultural and craft exhibits and riding competitions.

Bottom: Elk Lake, home to Canada's national rowing team, has been the training ground for many world and Olympic rowing champions.

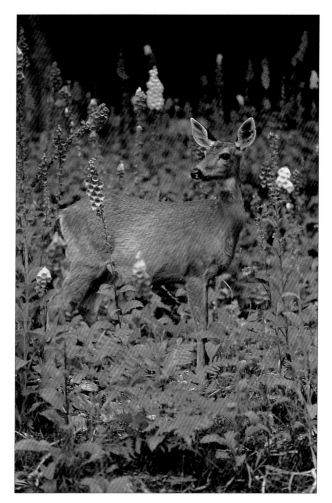

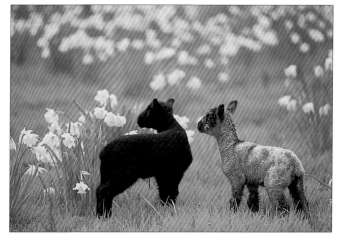

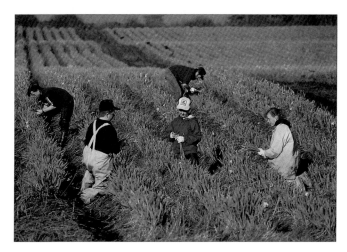

Top right: New lambs frolicking in a field of daffodils are a sure sign of spring on Vancouver Island and the Gulf Islands.

Middle: In the All Sooke Days logger sports competitions, this couple works the old "misery whip."

Bottom: The annual daffodil harvest in March is shipped around the world.

Above: An indigenous blacktail doe among foxglove flowers

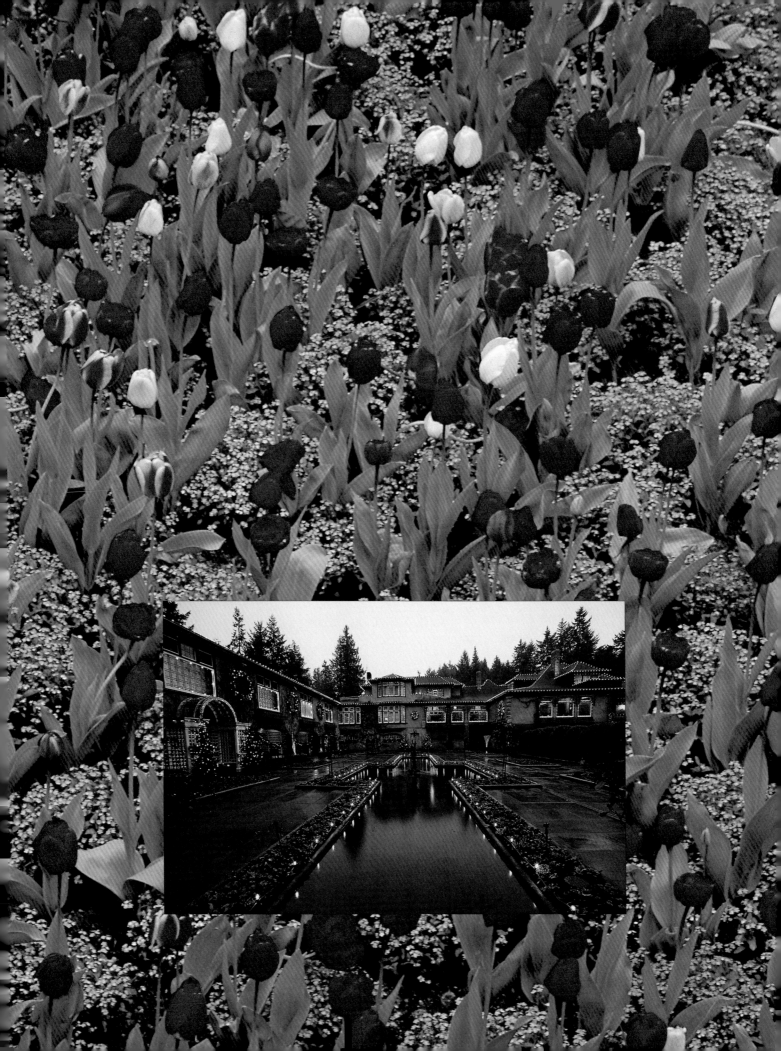

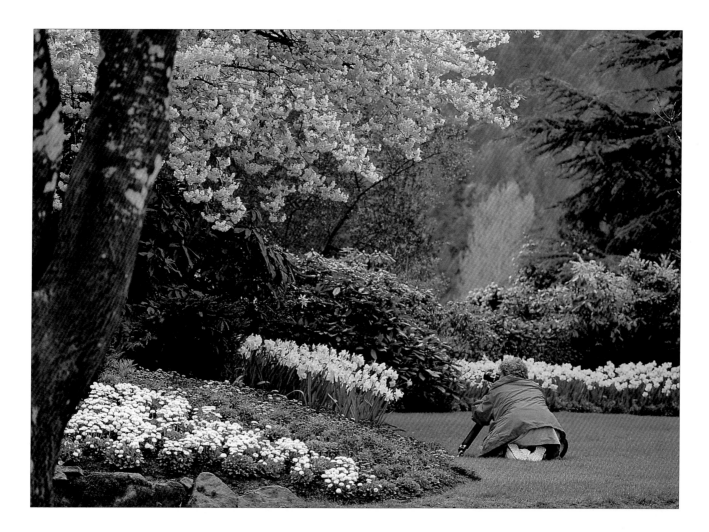

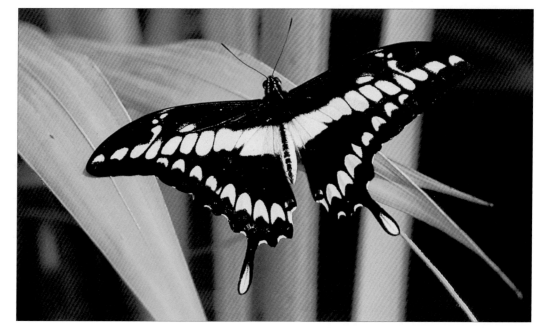

Top: The Butchart Gardens delights photographers with its collection of spring blossoms.

Bottom: Victoria Butterfly Gardens (and Coombs Butterfly World) feature exotic specimens.

Opposite: Forget-me-nots surround some of The Butchart Gardens' 50,000 tulips.

Opposite inset: The Butchart Gardens celebrates the Christmas holiday with a brilliant light display from December 1 to January 6.

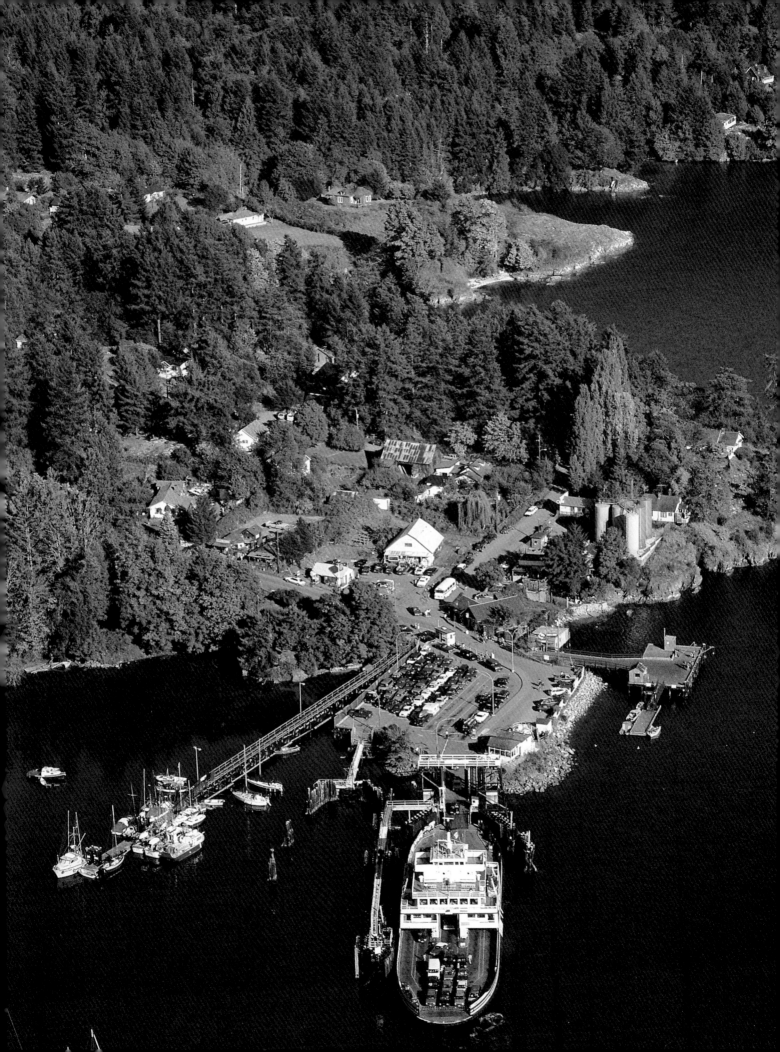

GULF ISLANDS

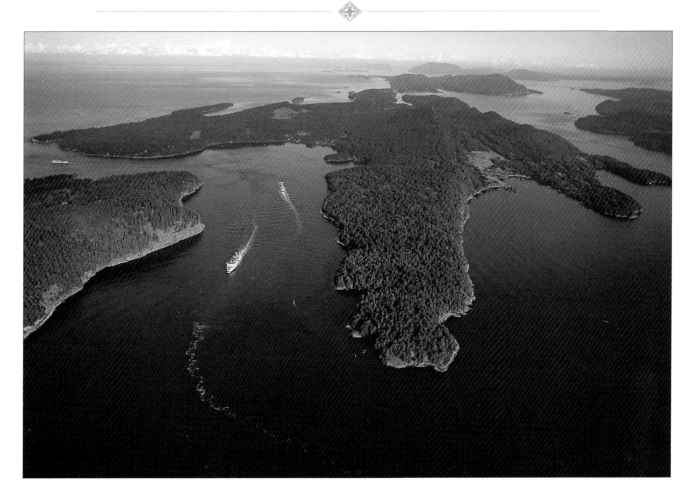

Top: Aerial view of BC Ferries in Active Pass, Mayne Island (right) and Galiano (left)

Opposite: Fulford Harbour, one of three ferry terminals on Salt Spring Island, provides access to Swartz Bay (Victoria).

Nestled in the rain shadow of Vancouver Island, in the protected waters of the Strait of Georgia, the Gulf Islands of Salt Spring, Pender, Saturna, Mayne and Galiano are reached by BC Ferry services at Swartz Bay.

Salt Spring Island, with its 10,000 residents, is by far the largest of the southern islands. The summer Saturday markets at Ganges showcase the talents of the islanders whose booths feature an array of hand-crafted products.

Both North and South Pender islands are popular yachting destinations. On Galiano Island, a 25-kilometre finger of land, Dionisio Point Provincial Park and Montague Harbour Provincial Marine Park feature some of the finest sandstone cliffs and white shell beaches anywhere in the Gulf.

Saturna Island, the site of the annual Canada Day lamb barbecue at Winter Cove Provincial Marine Park, is the least frequented, as this island of 300 residents has little tourist infrastructure. However, Mt. Warburton Pike, East Point and its unspoiled nature make this an appealing island getaway.

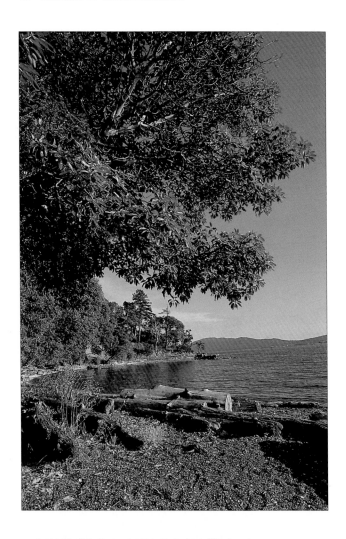

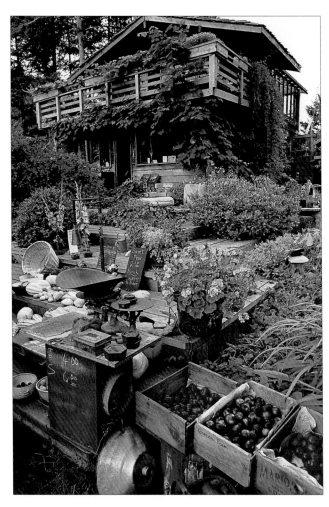

Top left: A bark-shedding Arbutus tree flourishes over a Tent Island beach, south of Kuper Island.

Top right: Organic market garden on Hornby Island, near Ford's Cove

Bottom: Linnaea Farm on Cortes Island provides training in organic farming practices.

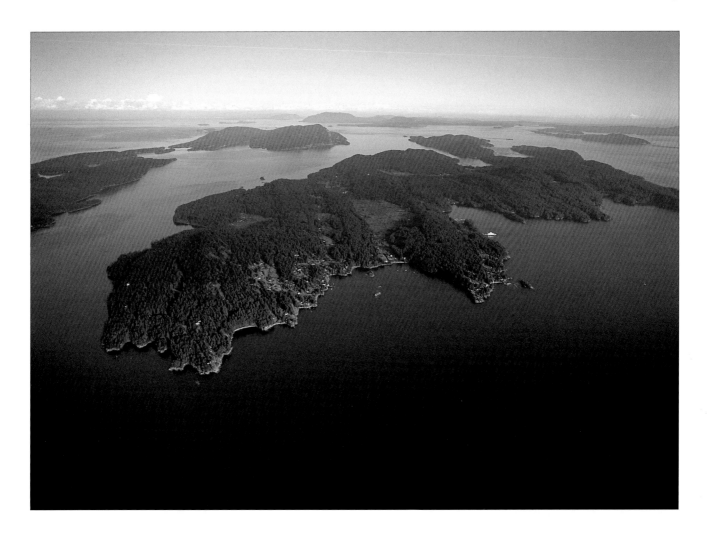

Top: North and South Pender islands with Mayne (left) and Saturna islands. To the right are Boundary Pass and the U.S. Islands.

Bottom: Port Browning Marina on North Pender offers quiet beaches, cabins, camping, playing fields, tennis, an outdoor pool and a rustic pub.

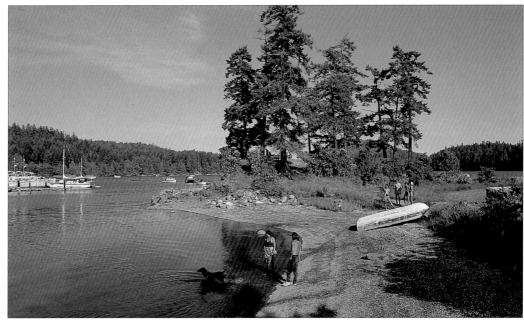

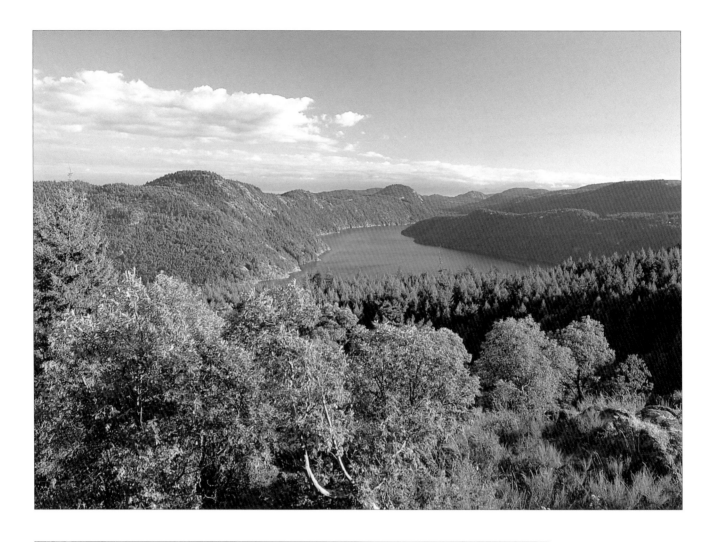

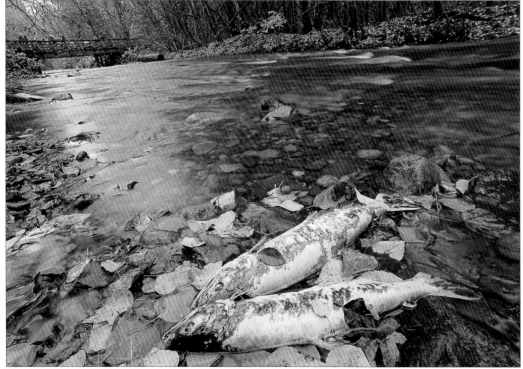

Top: From the top of the Malahat are sweeping views of Saanich Inlet and as shown, Finlayson Arm.

Bottom: Spent chum salmon line the riverbanks at Goldstream Park each November. Thousands of visitors take in the spectacle within half an hour of Victoria.

COWICHAN

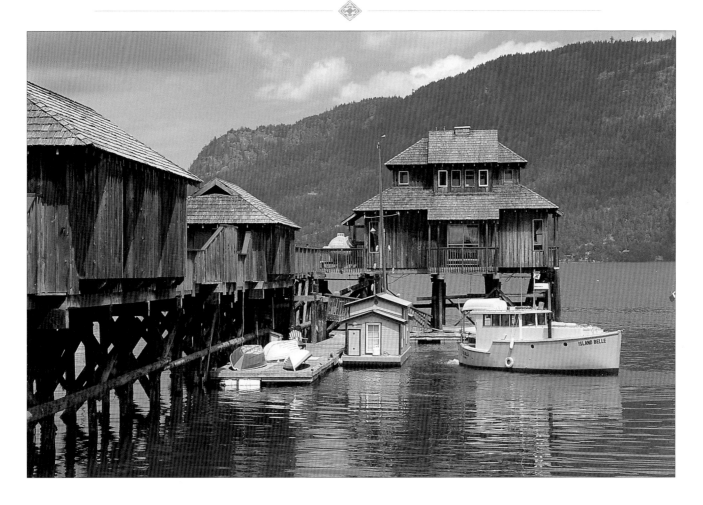

Top: Cowichan Bay Maritime Centre features boat building, cultural and historical exhibits of the Cowichan Estuary.

In the misty meadows of the Cowichan Valley, local vineyards offer tours and tasting of first-rate products around Cobble Hill. The maritime village of Cowichan Bay boasts herons and osprey, only two of the 200 species of birds that frequent the delta. Cowichan Bay Maritime Centre features local historical and nautical exhibits.

At Duncan, the City of Totems, the Cowichan Band shares its cultural traditions at The Cowichan Native Village. Downtown, yellow footprints lead to 41 of 80 totem poles featured on a self-guided tour.

Cowichan River and Lake are renowned for fishing. Beyond it stand the giant trees of Carmannah Walbran Provincial Park.

A horse-drawn tour of Chemainus is a relaxing way to see its colourful outdoor murals, which depict the region's vibrant history.

Ladysmith's Edwardian architecture evokes a nostalgic atmosphere. On the last Thursday of November, the streets are alight with colour at the annual "Festival of Lights."

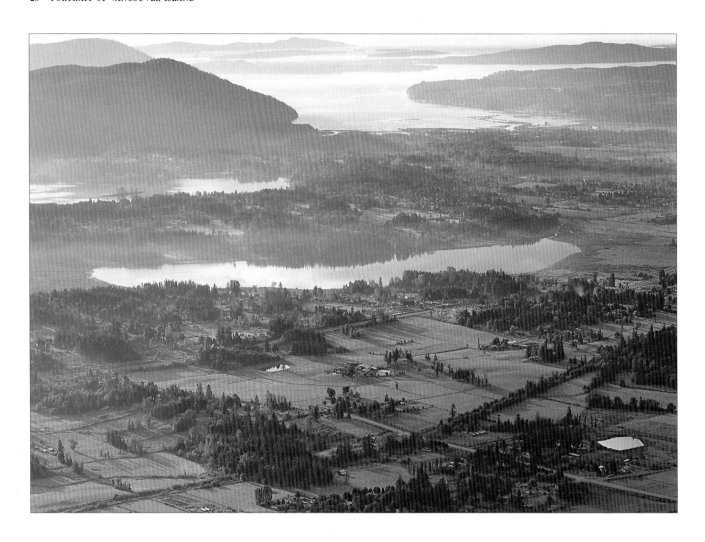

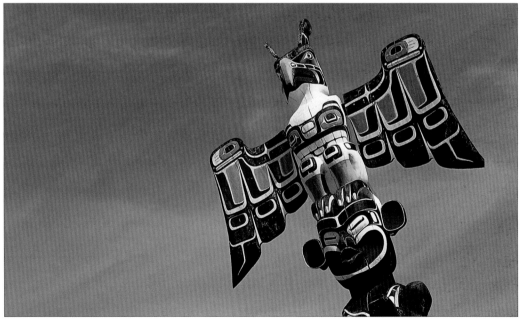

Top: Cowichan Valley. This viewpoint from Mt. Prevost shows Somenos Marsh (foreground), Quamichan Lake and Cowichan Bay (beyond).

Bottom: *Thunderbird above Tsonoqua* (Wild Woman of the Woods), by Ned Matildi, is one of 41 totems along the yellow footprints of a self-guided tour in Duncan.

Top: Sunrise over Ladysmith Harbour looking southeast

Bottom: This narrow-gauge Cowichan Valley Railway steam train gives visitors an overview of the 100-acre site of the British Columbia Forest Museum just north of Duncan.

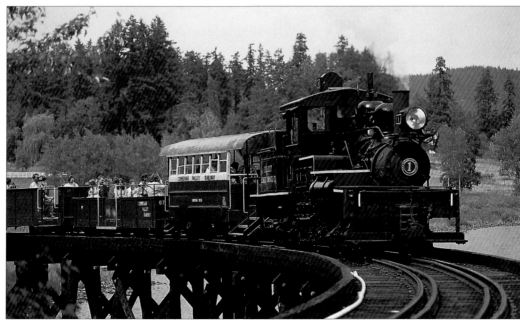

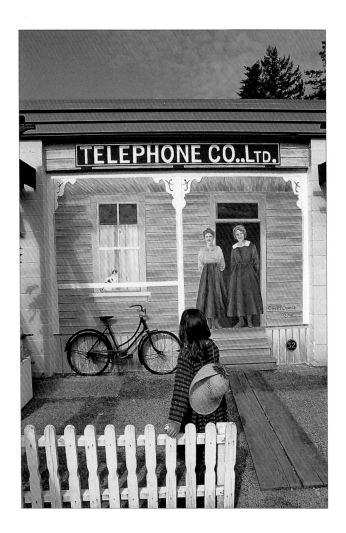

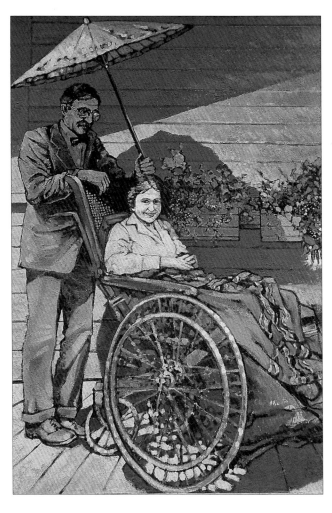

Top left: One of over 33 Chemainus murals—*The Telephone Company*, c.1915—painted by Cim MacDonald

Top right: Detail from the mural, *Chemainus Hospital* by Doug Driediger, features Mrs. Ruth Heslip and Dr. Herbert Burritt Rogers.

Bottom: Chemainus Theatre Company and shops

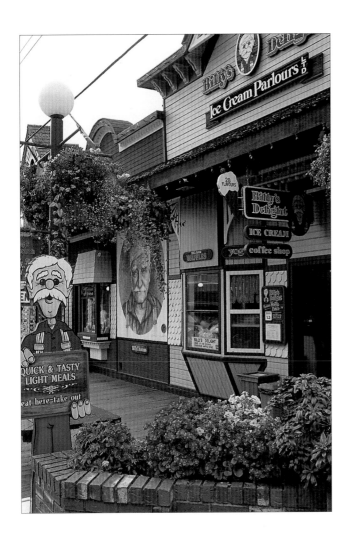

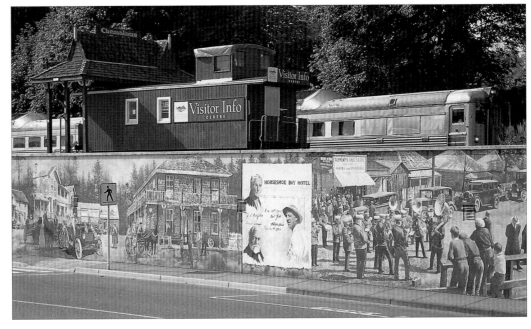

Top left: The ice cream parlour on Willow St. features Sandy Clark's mural of Billy Thomas, the first European child born in the valley, who lived to be 102 years old.

Top right: *Native Heritage* by Paul Ygartua celebrates the Cowichan people, the First Nation of the valley.

Bottom: *World in Motion* by Alan Wylie is a montage of historic events and buildings from 1883 to 1939. The E & N Dayliner stops here twice daily on its run from Victoria to Courtney and back.

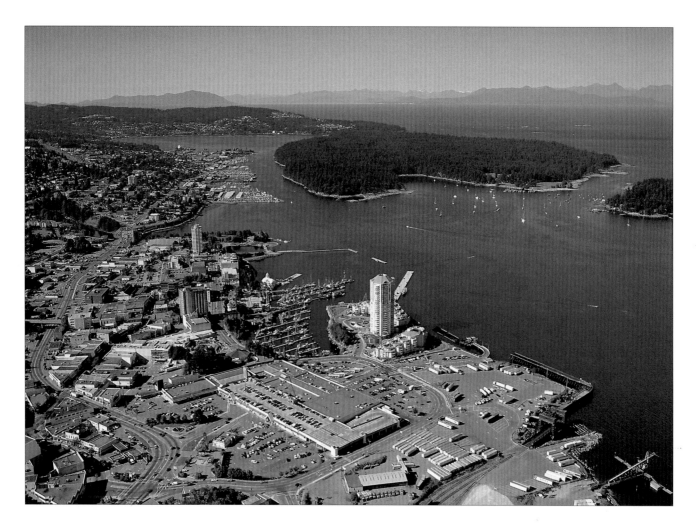

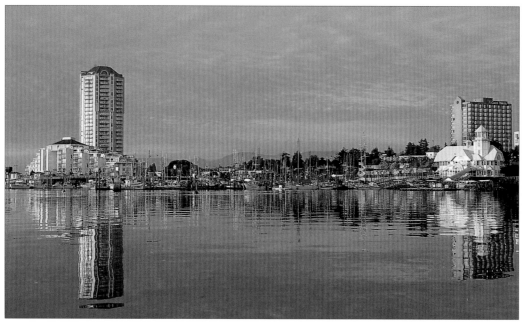

Top: Aerial of downtown Nanaimo, Newcastle Island with Departure Bay in the distance. The Coast Mountains of the mainland rise across the waters of Georgia Strait.

Bottom: Nanaimo Boat Basin, featuring the Bastion and Pioneer Waterfront Plaza on the right

MID ISLAND

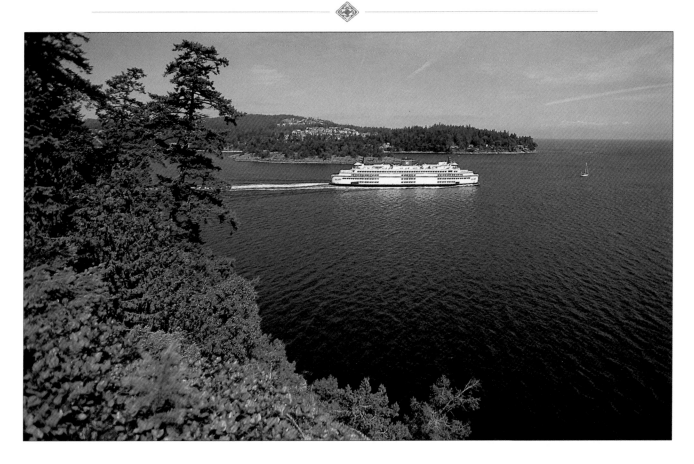

Top: A BC Ferry leaves Departure Bay for Horseshoe Bay (North Vancouver). This is the view from the overlook on Newcastle Island Provincial Marine Park.

Nanaimo's delightful four-kilometre Harbourside Walkway winds along the city's fore shore, past the colourful Fisherman's Wharf and through parks toward Departure Bay. En route, enjoy gourmet coffee or fish and chips alfresco, and discover the last surviving Hudson's Bay Company Bastion in North America, built in 1853.

Visit Maffeo-Sutton Park's unique man-made saltwater lagoon, adventure playground, fishing pier and Newcastle Island Ferry wharf along the way.

Salmon fishing, beaches and golf are the magnets that draw vacationers and newcomers alike to the balmy playgrounds of the Island's east coast. The waters warm in summer as tides creep slowly up the sun-baked beaches at Rathtrevor, Parksville, Qualicum and Hornby Island's Tribune Bay.

Coombs has always drawn passersby to stop. Its goats, which graze on the rooftop meadow above the popular Old Country Market, look down at the bustling spectacle below. Butterfly World and the Emerald Forest Bird Garden round out the attractions of the rustic village.

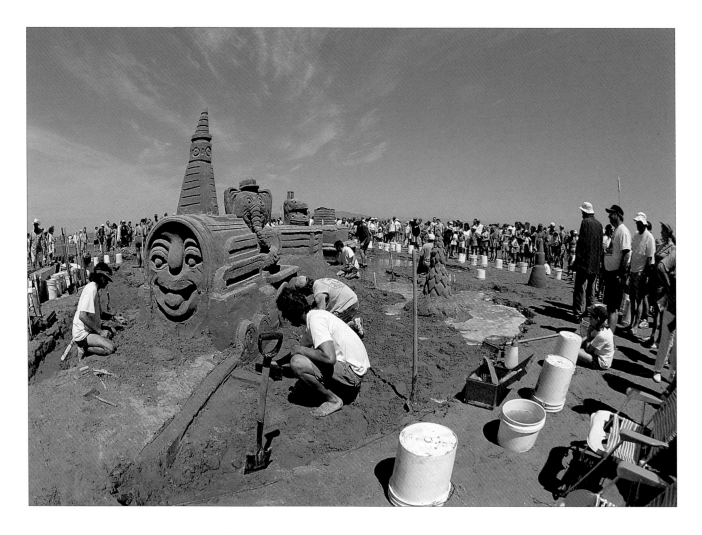

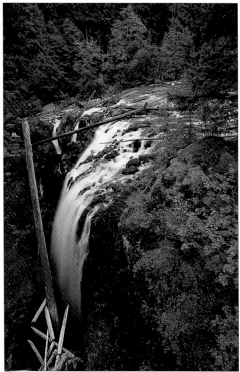

Top: The expansive sands of Parksville's beaches are perfect for sand sculpture.

Bottom: The upper falls at Englishman River Provincial Park as seen from one of the two footbridges that cross the river

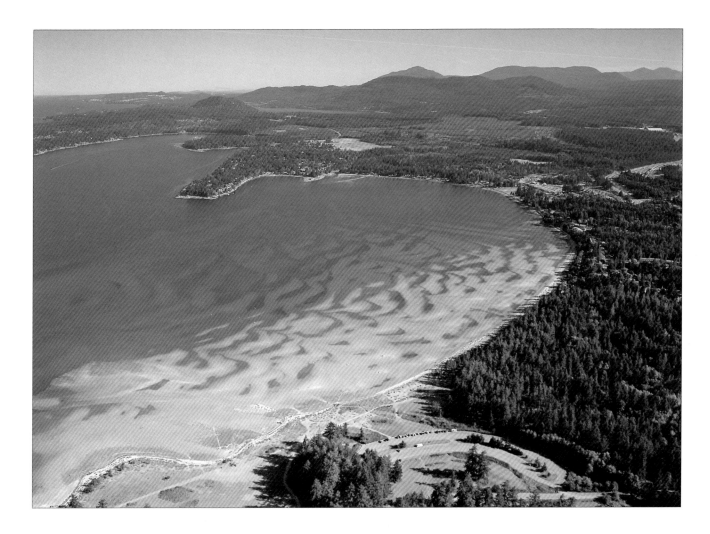

Top: The warm incoming tides during summer days delight swimmers at Rathtrevor Beach.

Bottom: Parksville, a very popular camping and resort area

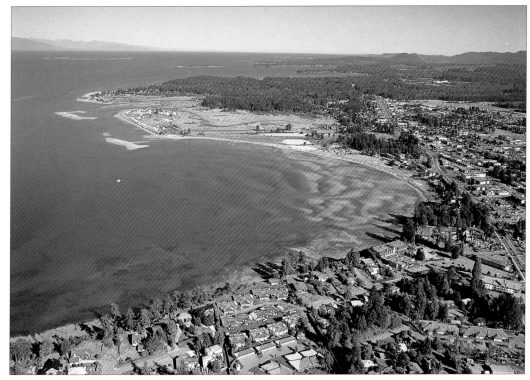

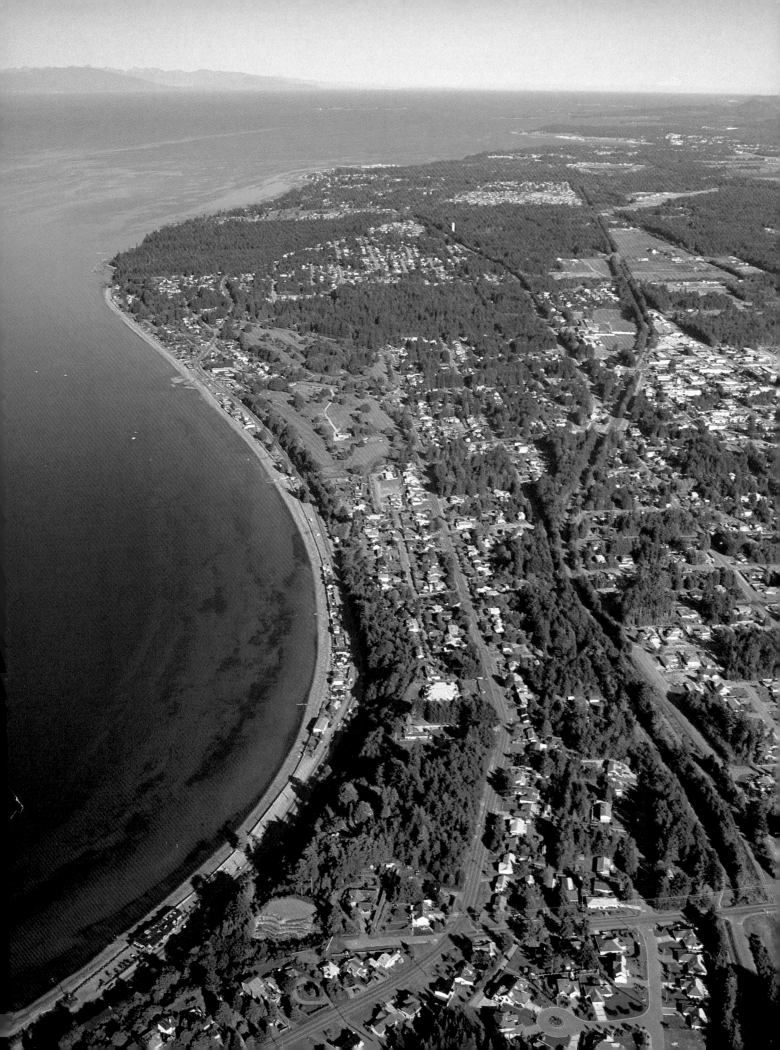

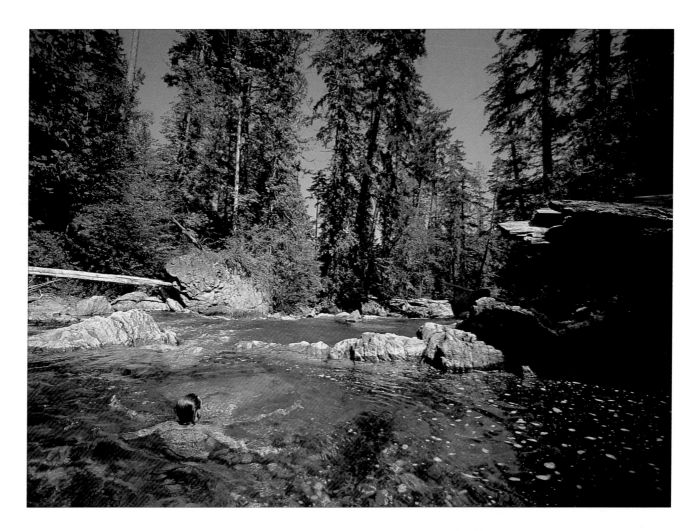

Top: Hiking trails at Little Qualicum Falls Provincial Park lead past scenic waterfalls to a series of clear green swimming holes. Camping and picnicking areas are provided.

Bottom: A Bear and Thunderbird totem at Qualicum Beach, illuminated at twilight

Opposite: An aerial of the rapidly growing Qualicum Beach area.

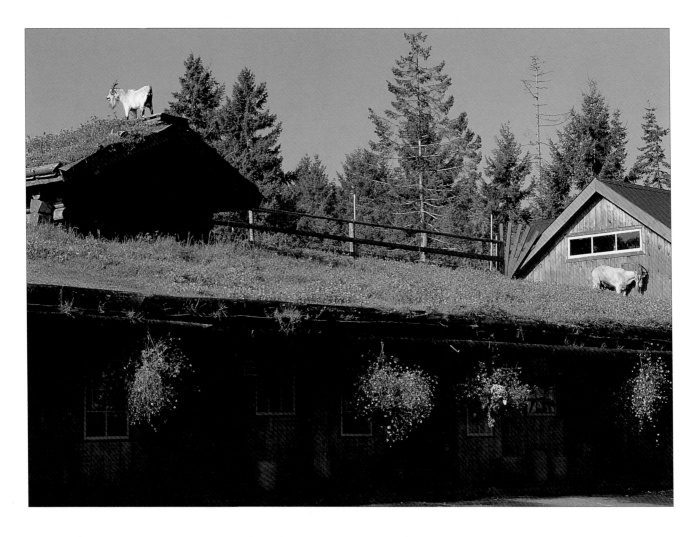

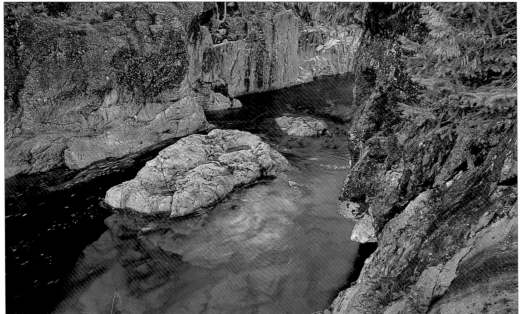

Top: Goats graze contentedly on the sod-roofed Old Country Market in Coombs.

Bottom: Smooth, polished rock and emerald waters make the Kennedy River, which parallels Highway 4, an ideal rest stop.

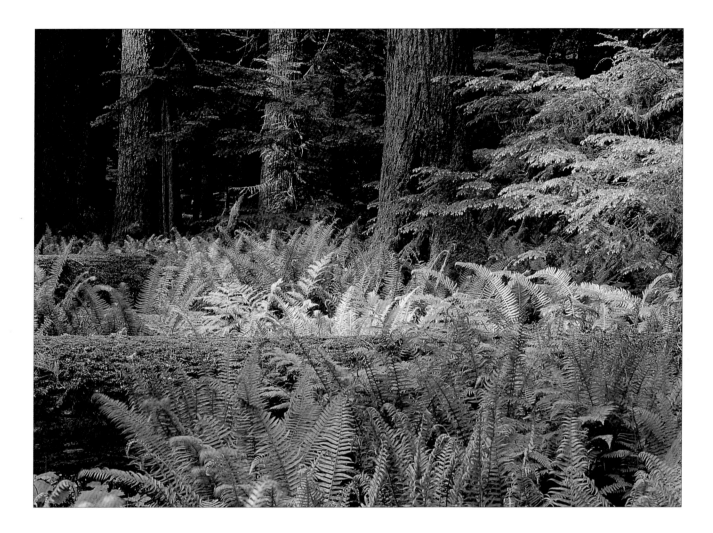

Top: In Cathedral Grove in MacMillan Park, just past Cameron Lake, is a prime old-growth Douglas fir stand. Trails run under a canopy of trees that are up to 800 years old.

Bottom: Cathedral Grove trees stretch their trunks upwards toward the sky.

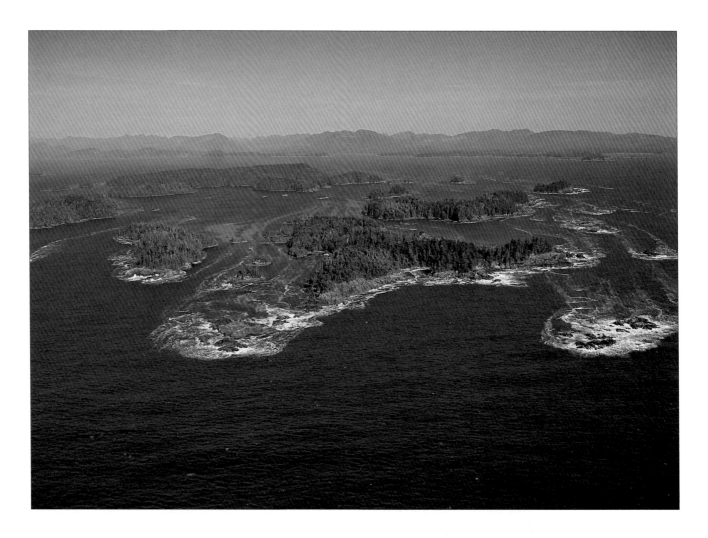

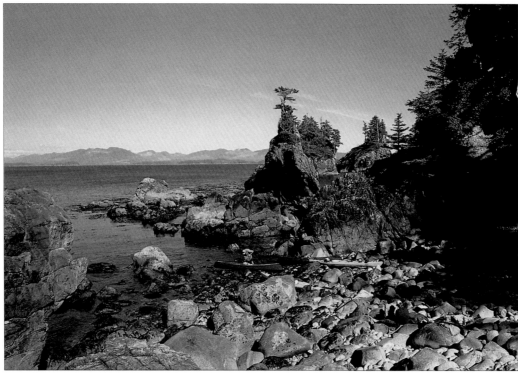

Top: The Broken Group Islands in Barkley Sound, Wouwer and Howell Island. This section of Pacific Rim National Park is a popular paddling destination.

Bottom: Hungry paddlers haul up for lunch on a rocky Austin Island beach in the Broken Group (photo by Janice Cheadle).

PACIFIC RIM NATIONAL PARK

Top: A lone fishing boat heads up the Alberni Inlet near Bamfield.

Dominating the landscapes east and west, from Parksville to Port Alberni, is Mount Arrowsmith. At 1,817 metres high, it was once thought to be the highest mountain on the Island. Just before entering Port Alberni, a 90-kilometre gravel road leads to Bamfield. Settled in 1859, it became the eastern terminus of the transpacific telegraph cable in 1902. Its buildings now house the Bamfield Marine Station, a cooperative marine biology research centre for five western Canadian universities. Bamfield is perhaps better known for its access to the ruggedly scenic West Coast Trail, which challenges 8,000 hikers annually. Reservations and fees are now necessary, with limited accommodations for daily walk-ons.

Port Alberni, which vies for the title of "Salmon Capital of the World" with Campbell River, is renowned for its dependable salmon runs, largely aided by the nearby Robertson Creek Hatchery. The narrow Alberni Inlet conveniently funnels migrating schools of salmon and steelhead from the coastal waters, past a flotilla of eager anglers (few of whom are disappointed)

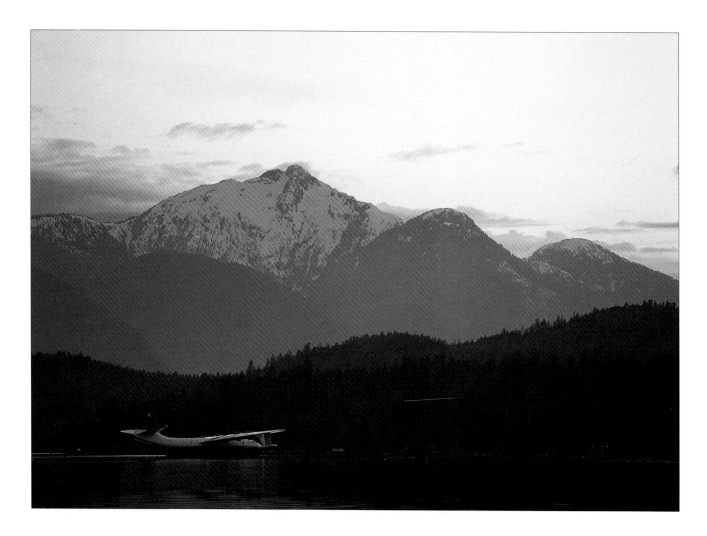

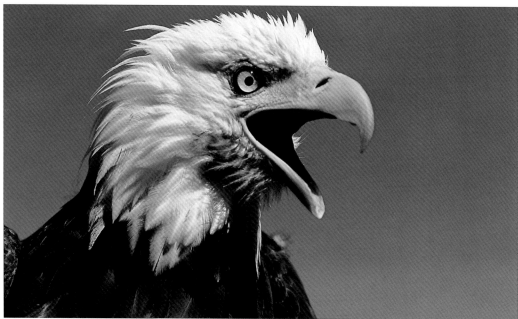

Top: The Martin Mars "flying tanker," the world's largest, floats at its moorings on Sproat Lake near Port Alberni.

Bottom: Bald eagle

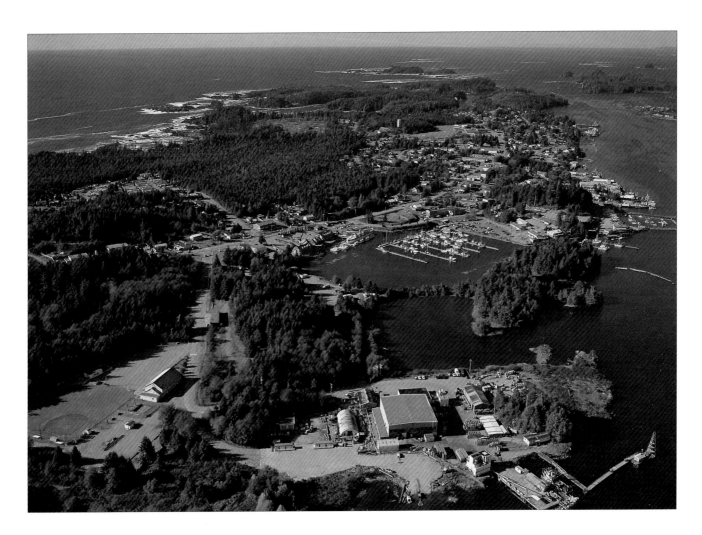

Top: Ucluelet, at the south end of the Pacific Rim area, retains its roots as a West Coast working village with canneries lining Ucluelet Harbour.

Bottom: Adjacent to world class salmon and halibut fishing, scuba diving and marine wildlife viewing lies Ucluelet Harbour. The Canadian Princess serves as a permanent floating hotel to accommodate the many visitors.

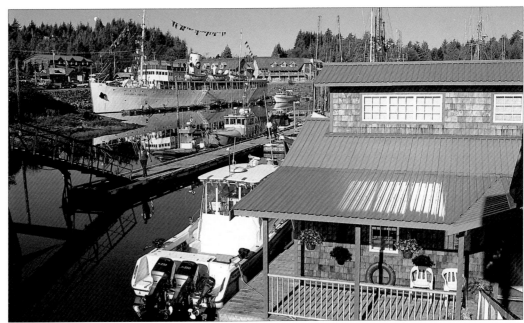

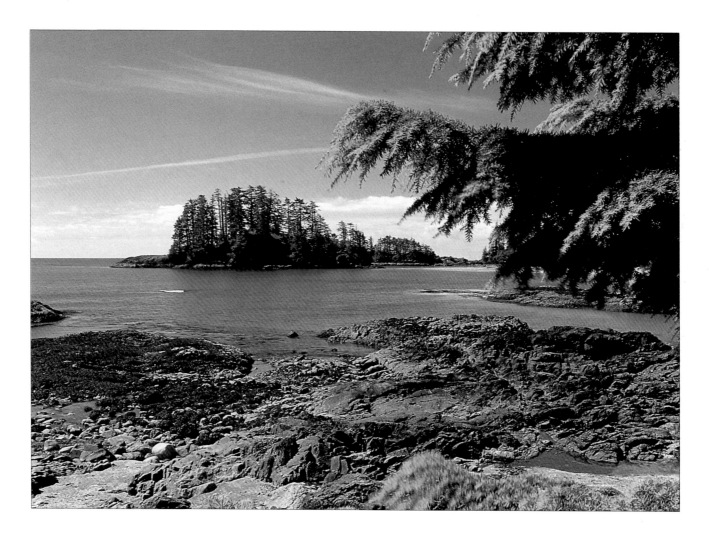

during peak flows. Each Labour Day weekend, the Port Alberni Salmon Festival celebrates this bounty by awarding major cash prizes at sizzling salmon barbecues.

Stamp Falls Provincial Park is a must-see in September and October. At this time, the pools below the falls teem with returning schools of chinook, coho, sockeye and steelhead. Great Central Lake is the gateway to Della Falls, Canada's highest at 440 metres. The vast sand beaches and wave-battered headlands of the West Coast draw us to Tofino, Pacific Rim National Park and Ucluelet.

The Wickaninnish Centre, with its natural history exhibits, restaurant and spotting scopes, is an excellent place to start. The beach itself, with trails to Florencia Bay and Combers Beach, is a favorite of surfers and beachcombers alike. The Shoreline Bog Trail is a fascinating and somewhat surreal mini-environment of stunted pines and mosses.

Long Beach, regarded as the longest stretch of sandy beach on the West Coast, is the feature attraction. With the federal campground at Green Point

(continued on page 51)

Top: This delightful beach is well worth the hike into Schooner Cove, part of Pacific Rim National Park, just north of Long Beach.

Opposite: Rocky headlands and fine sand beaches fringed by thick spruce forests just north of Schooner Cove typify the West Coast.

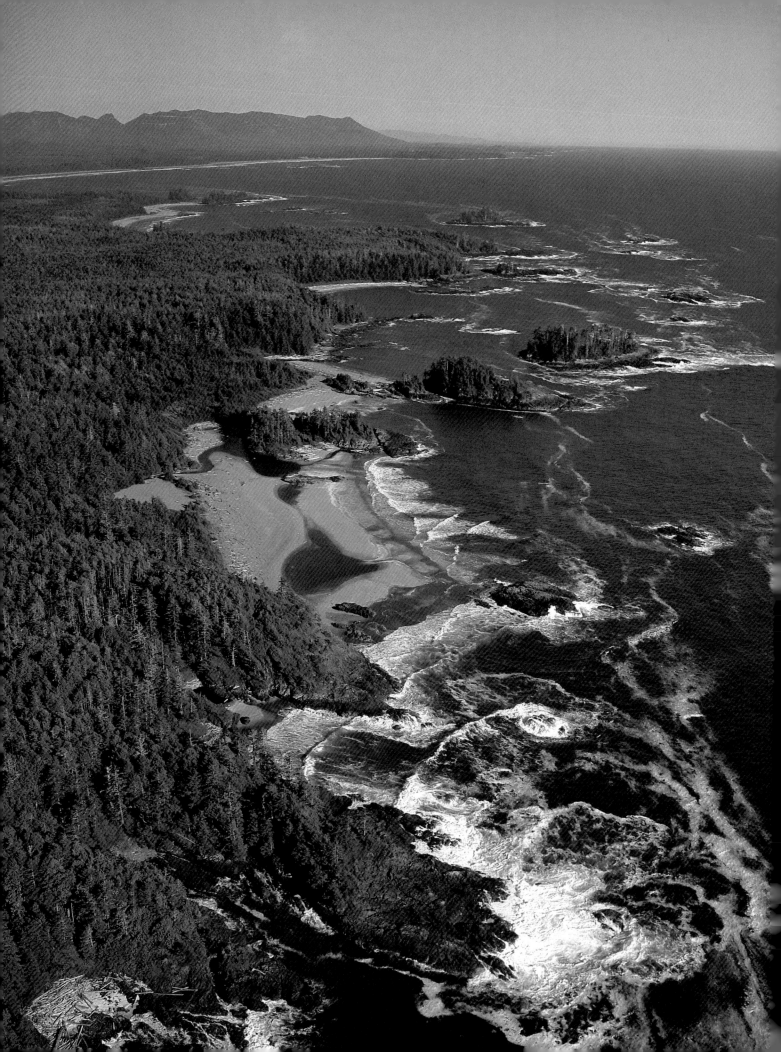

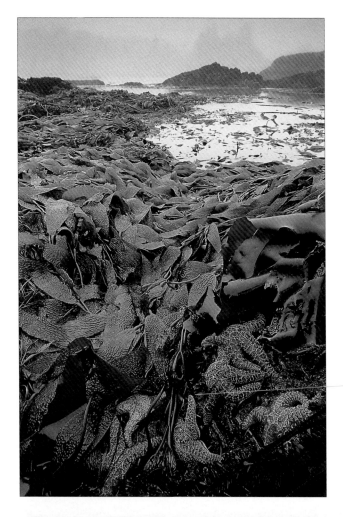

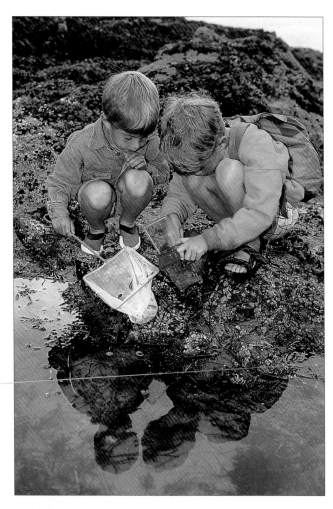

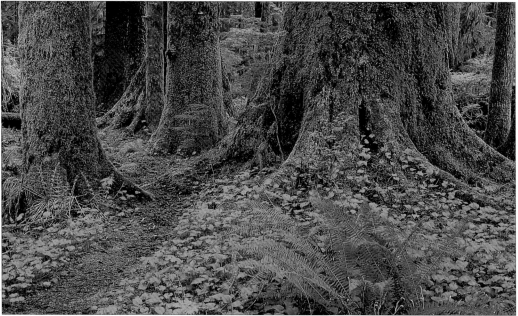

Top left: Summer's low tides reveal orange and purple ochre sea stars among the kelp on a small island at MacKenzie's Beach.

Top right: Kids are fascinated by the plethora of marine creatures in the rocky tide pools.

Bottom: The warm, wet climate sustains a verdant carpet of ferns and vanilla leaf under the canopy of this rain forest.

Opposite: The Wickaninnish Centre on its namesake beach features interpretive displays and a first-rate restaurant.

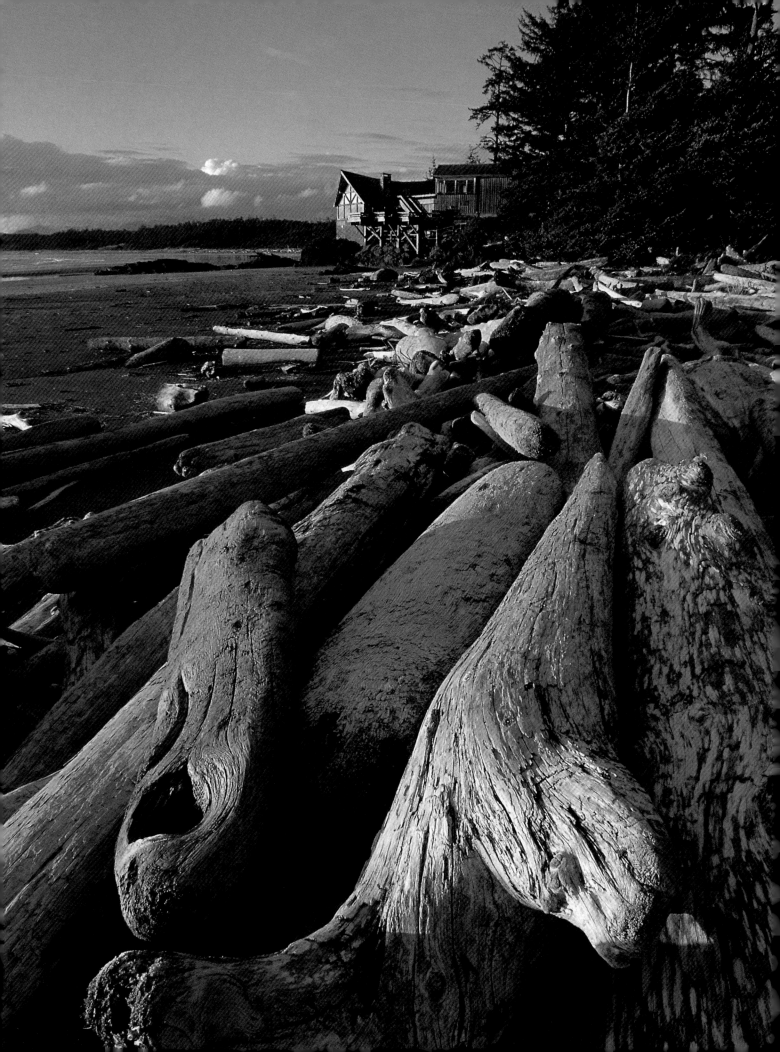

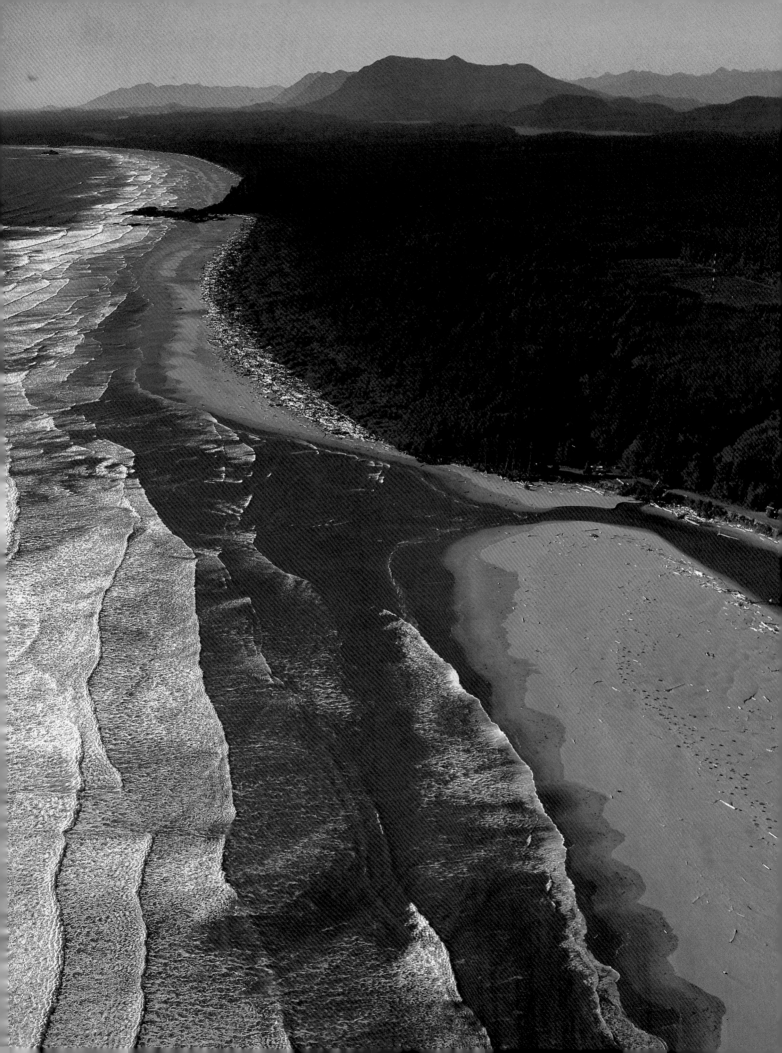

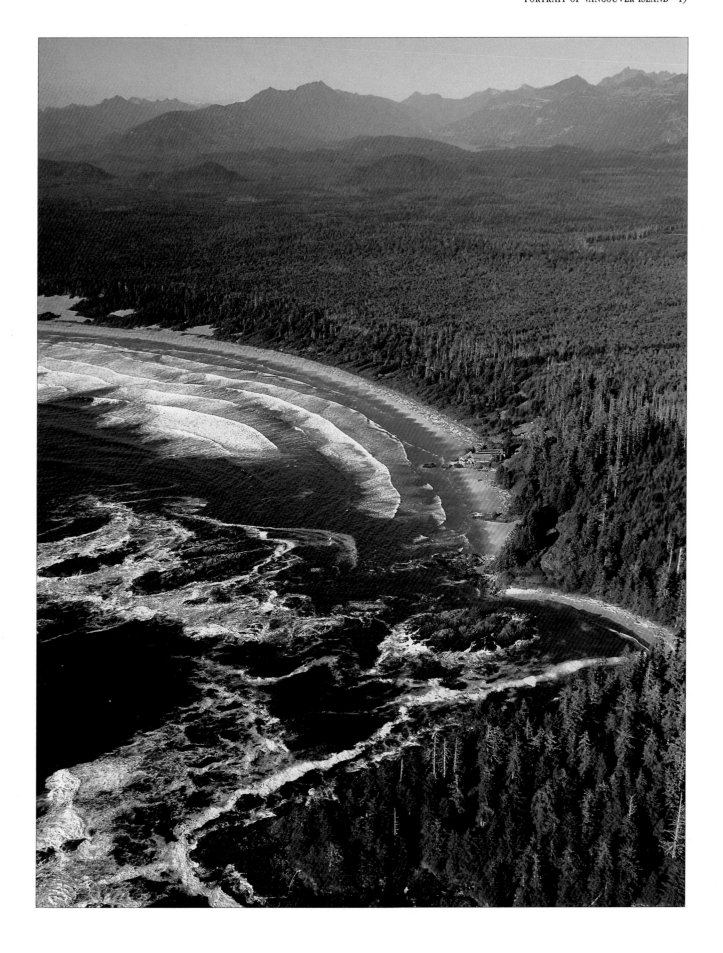

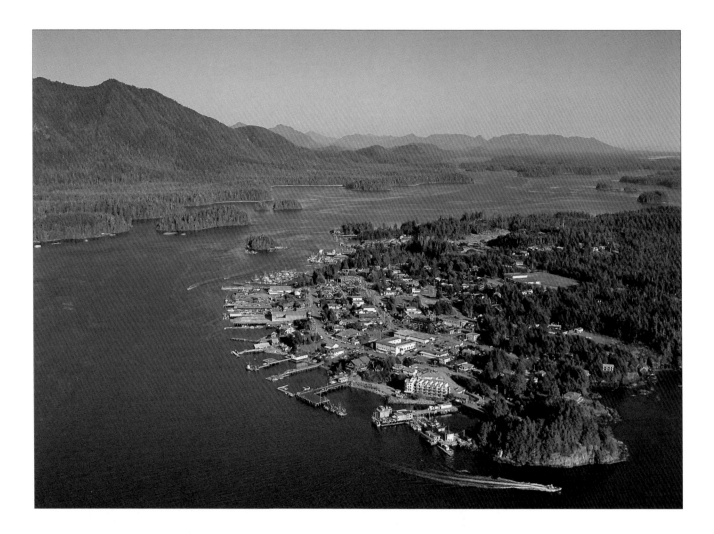

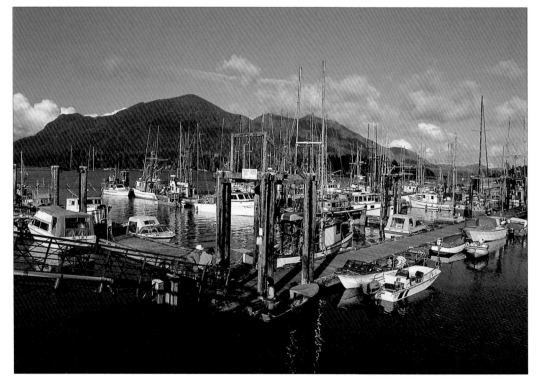

Top: Village of Tofino; Tofino Inlet with Meares Island rising up on the left

Bottom: Tofino Government Wharf with Meares Island beyond

Previous pages:

Left: A roaring surf rolls up Combers Beach as we look north toward Long Beach and Meares Island.

Right: Aerial view of Wickaninnish Beach (top) with Lismer Beach (right), a favorite painting location of its Group of Seven namesake, Arthur Lismer

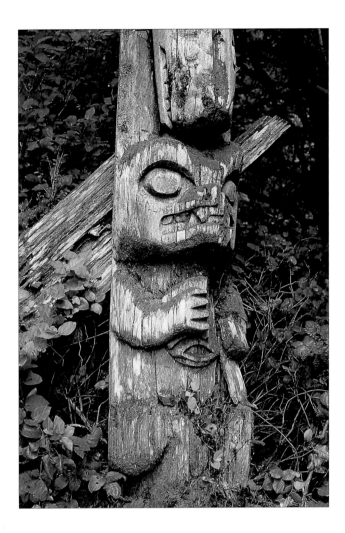

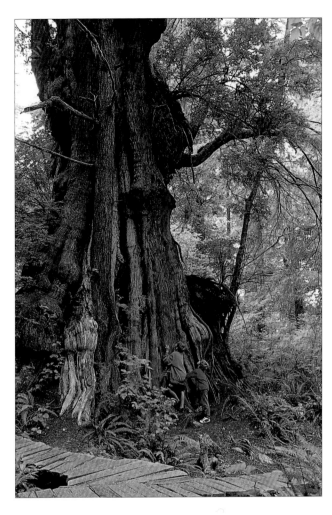

Left: Nuu-Chah-Nulth pole at a deserted West Coast village site north of Kyuquot

Right: The famous hanging garden cedar tree on the nature trails of Meares Island

to the south and the quiet, day-use-only Schooner Cove to the north, one can walk the surf-packed sands all day.

In the summer, very low daytime tides expose fascinating tide pool worlds on rocky outcrops. Carpets of mussels and barnacles, starfish and a rich soup of kelps and seaweeds vie for their rocky footholds. Radar Hill, accessible by car and wheelchair, provides a dramatic view of Clayoquot Sound.

Tofino, a maritime town of just over 1,000 residents, sits atop the Esowista Peninsula across from the forested shores of Meares Island and the Nuu-chah-nulth village of Opitsat. Today's indigenous residents, as well as the loggers, fishers, artists, service workers, urban refugees and young transients, are engaged in ongoing dialogue to ensure that their lifestyles continue to coexist in relative harmony with this priceless environment.

Ucluelet, on the north edge of Barkley Sound, is a working coastal village. Trollers, seiners, crabbers or draggers are usually chugging in and around the canneries or wharves.

The Broken Group and Clayoquot Sound offer some of the very best sea kayaking experiences available on the planet.

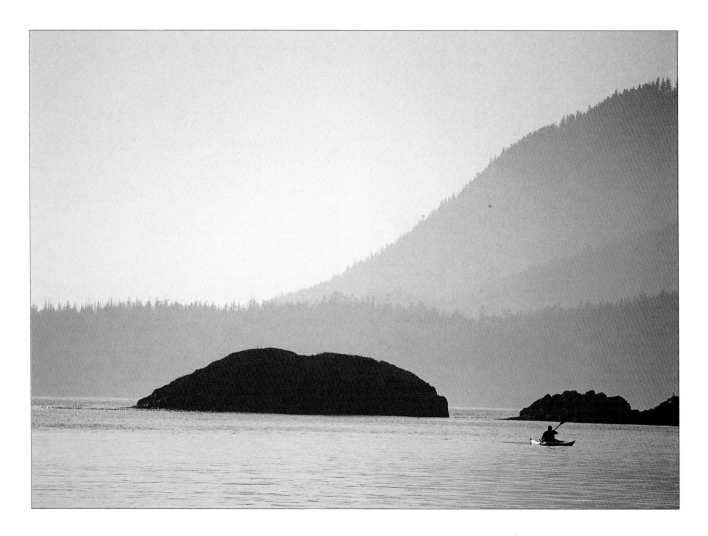

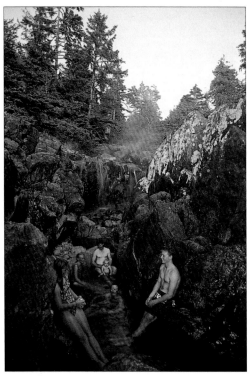

Top: A lone sea kayaker slips into a quiet bay on Flores Island at sunset.

Bottom: Bathers enjoy a hot soak in the rock pools of Hot Springs Cove, accessible by air or water only, from Tofino.

Opposite: Hot mineral waters emerge from an underground spring and course their way to the pools at Hot Springs Cove.

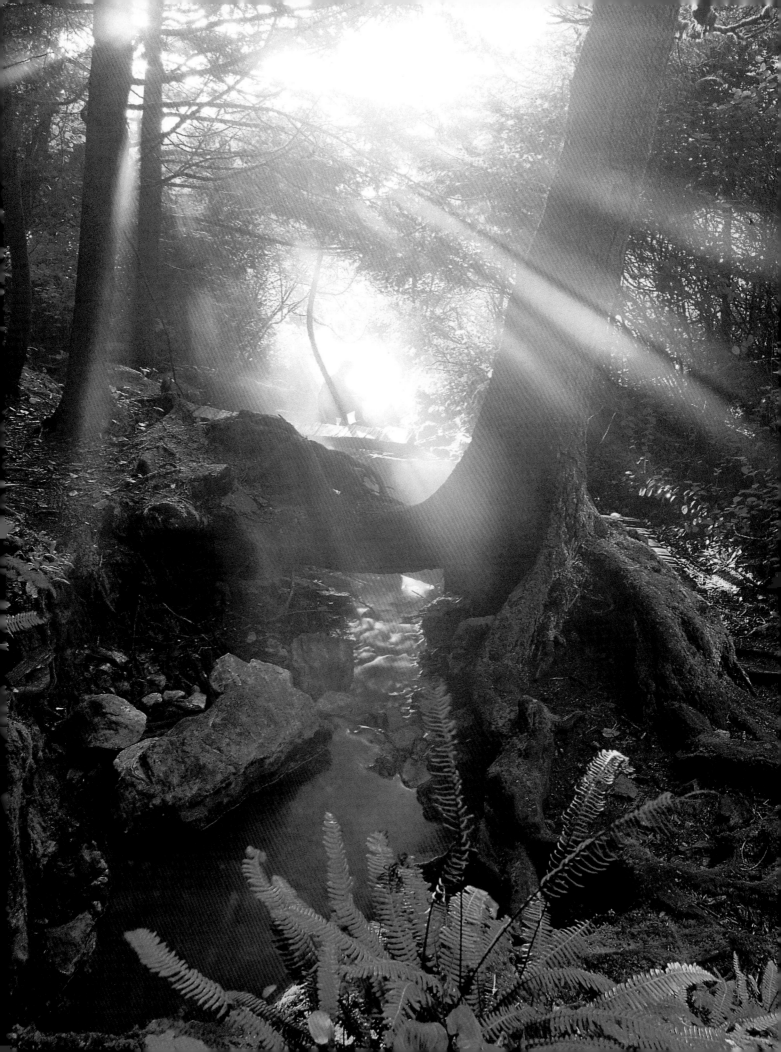

COMOX & NORTH ISLAND

Top: Comox Glacier or "Queneesh" dominates the alpine backdrop as seen from Comox.

Opposite: The force of wind and wave carved this sandstone abstract at the entrance to Hornby Island's beautiful Tribune Bay Provincial Park.

The fertile Comox Valley, from Courtenay to Campbell River, basks in the lee side of the island's mountainous spine. Its snow-capped peaks, alpine meadows, lakes, rivers and streams are home to Roosevelt elk, deer, marmots, cougars, black bears and wolves. Adjacent to the park lies Mt. Washington, the island's premier skiing resort.

The valley floor, an ancient sea bed, provides a fertile base for its prolific farming community. Fossils of three extinct reptile groups were discovered in 1991, and the remains of a 13-metre Elasmosaur are proudly displayed in the Courtney Museum.

Johnstone Strait funnels millions of migratory salmon past the shores of Campbell River. Hailed as the "Salmon Capital of the World" for 100 years, the area's Discovery Pier has seen hundreds of anglers land prize salmon with hooped landing nets that are lowered from the boardwalk.

Pods of orcas, Pacific white-sided dolphins and schooling salmon attract a constant stream of visitors to Telegraph Cove, a rustic boardwalk community south of Port McNeill that pioneered the whale-watching industry.

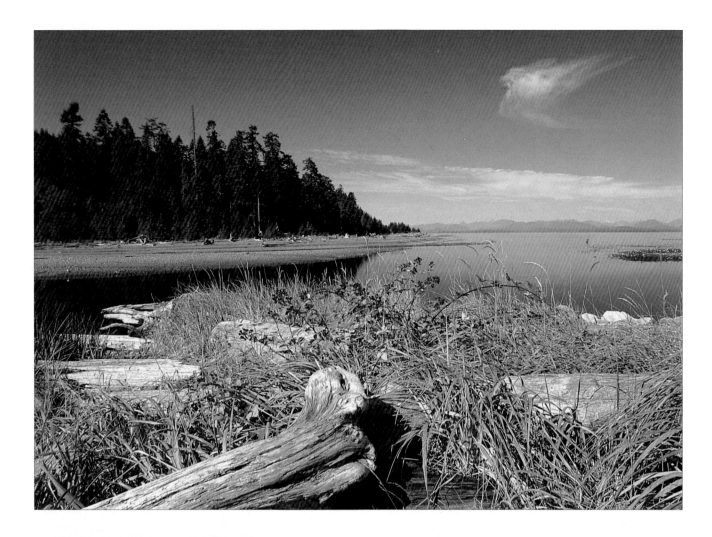

Top: The Oyster River Estuary at Saratoga Beach offers prime fishing opportunities, beautiful sandy beaches and spectacular mountain panoramas across the Strait of Georgia.

Bottom: The Goose Spit at Comox is a favorite beach for Valley residents. Lucky anglers sometimes beach coho from its shores.

Opposite: Proclaimed the "Salmon Capital of the World" for the last 100 years, Campbell River is at the south end of Johnstone Strait.

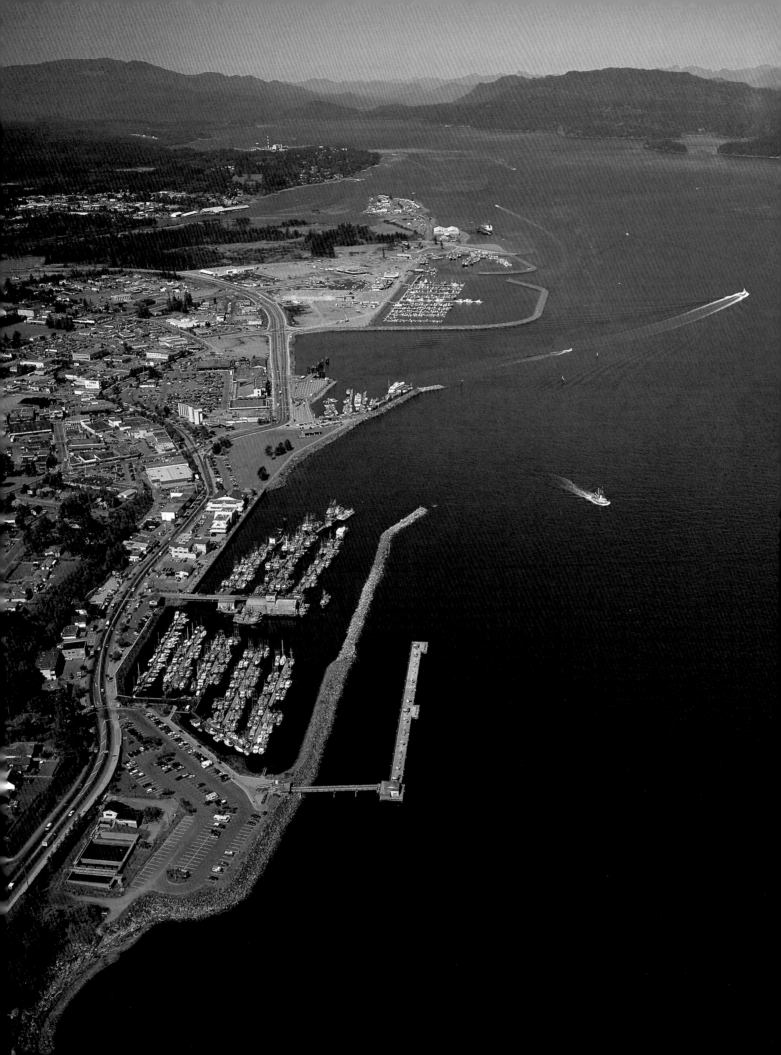

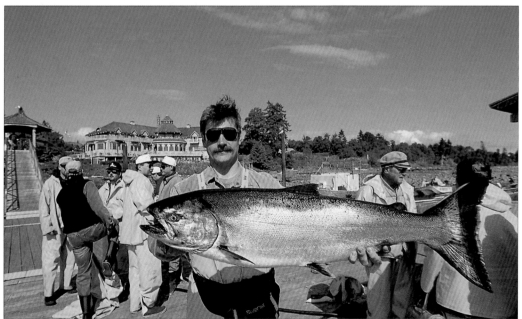

Top: The Discovery Pier affords anglers access to salmon-rich kelp beds fronting the town. On good days, anglers land dozens of salmon from the pier.

Bottom: This lucky visitor displays a 12-kilogram chinook salmon in front of the renowned salmon resort, Painter's Lodge, at Campbell River.

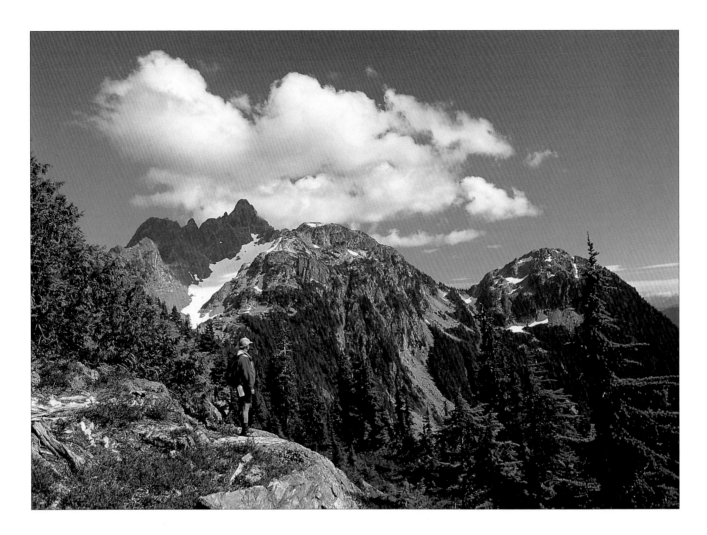

Top: In the heart of B.C.'s oldest park, Strathcona, a hiker pauses below Mt. Septamus. The park's many hiking routes reward the hardy with brilliant vistas, glaciers, valleys, waterfalls and alpine lakes.

Bottom: Port MacNeill Harbour and a 1938 Washington steam donkey. These engines powered a whole generation of logging and fueled the economy of Vancouver Island.

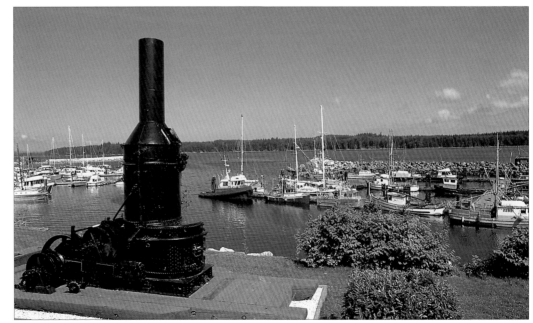

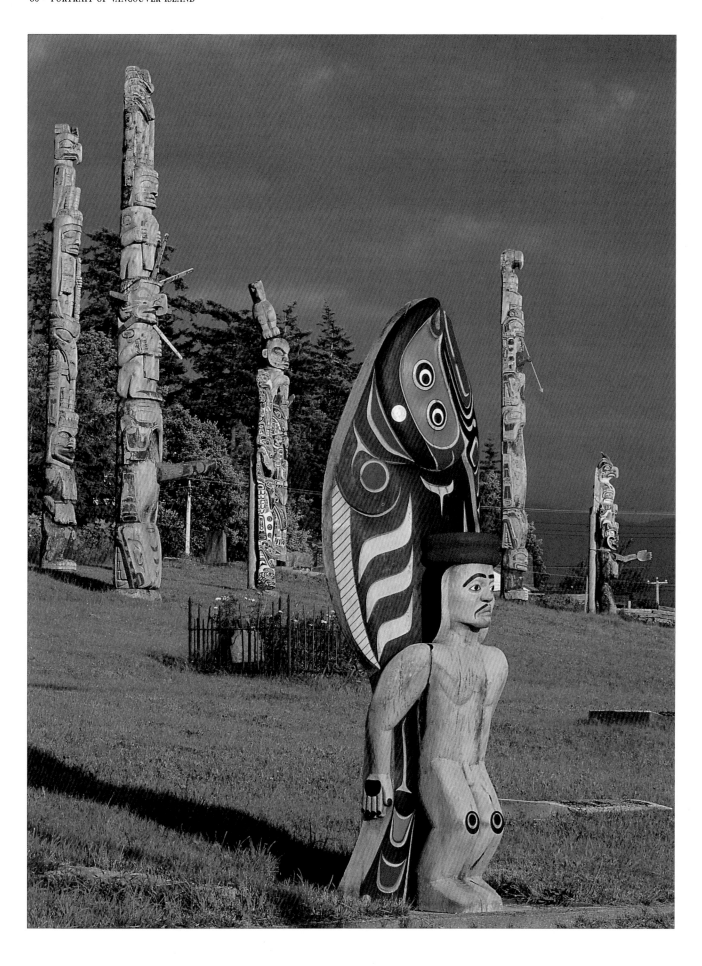

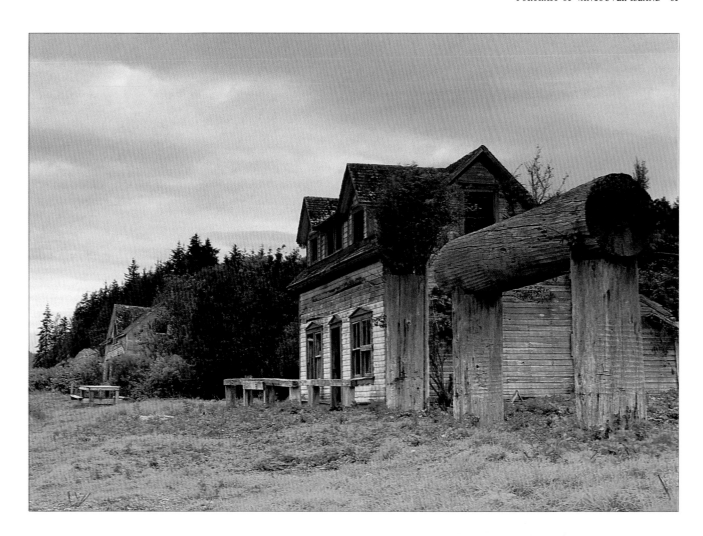

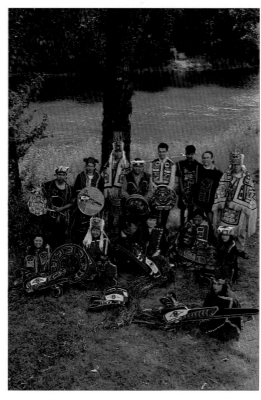

Top: Three phases of Mamalilaculla, a Kwakwaka'waka village in the Broughton Archipelago: traditional cedar house posts, a post-European dwelling and now, abandonment.

Bottom: The Kwagiulth dancers form Fort Rupert proudly display elaborate ceremonial drums, masks and costumes. This group has performed across Europe and North America.

Opposite: Nimpkish memorial burial ground at Alert Bay may be viewed from the road. This largely Kwakwaka'waka (Kwakiutl) village evokes a sense of past times with its cannery row and quiet atmosphere.

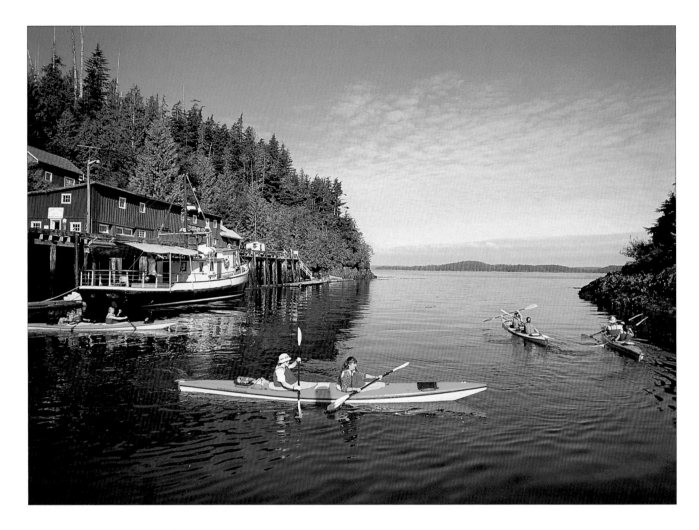

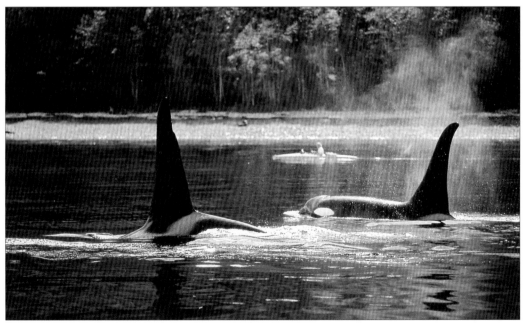

Top: A kayaking group sets out from Telegraph Cove. This rustic boardwalk community is noted for its whale-watching excursions, kayak charters and sport-fishing opportunities.

Bottom: Orcas and kayakers share the waters near Robson Bight.

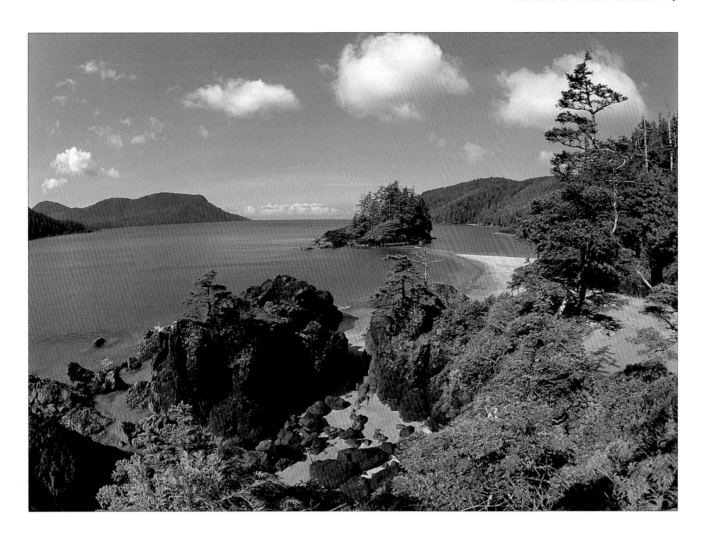

Top: A ninety-minute drive from Port Hardy and an easy, flat hike of 40 minutes takes visitors to the pristine beaches of Cape Scott Park's San Joseph Bay. A full day's hike leads to Cape Scott itself, with miles of untrammeled beaches and rugged wilderness.

Bottom: This eagle's tabletop on the Plumper Islands near Port MacNeil shows remnants of gull, abalone, urchin and fish bones.

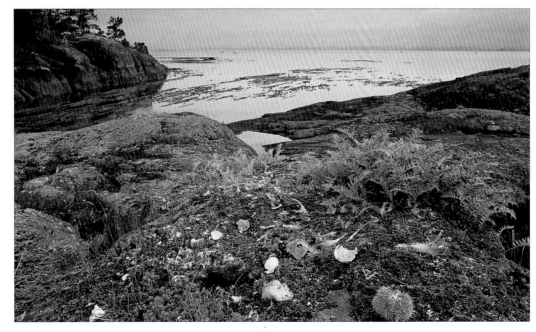

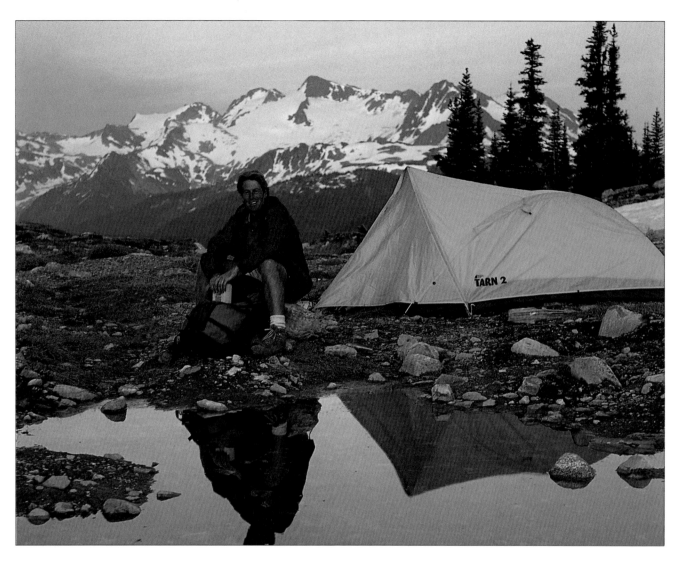

Top: Chris Cheadle has been fortunate enough to have called Vancouver Island his home for the last twenty years. In Sidney, north of Victoria on the Saanich Peninsula, he shares his love of the Island's magical places with his wife Jan, his two sons, Dylan and Evan, and his dog, Sparky. Chris's work has been featured in books, calendars, magazines and advertisements in Europe, Asia and North America. He is delighted to be able to share his impressions of the many splendors of beautiful Vancouver Island.